IMAGES
of Modern America

TED WILLIAMS AND FRIENDS
1960–2002

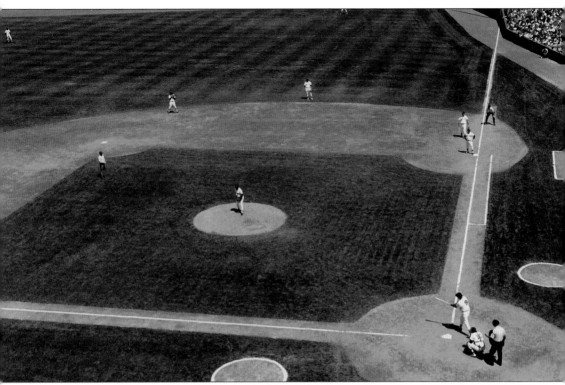

Ted Williams was in a familiar place—the batter's box at Fenway Park—during the 1984 Red Sox old-timers game. Here, the man who hoped to be known as "the greatest hitter who ever lived" takes a practice swing before pitcher Luis Tiant delivers. Note that even in an old-timers game the opposing team has a version of the Lou Boudreau Shift on against Williams—three infielders on the right side of the diamond, daring him to hit through the shift or try to beat it by hitting to the mostly vacant left side of the field. (Courtesy of the Trust Collection.)

On the Front Cover: Clockwise from top left:
In 1991, Pres. George H.W. Bush honors Ted Williams, center, and Joe DiMaggio, right, at the White House on the 50th anniversary of their historic achievements in the 1941 season. Williams batted .406 (no one has hit .400 since), and the Yankee Clipper ran off a 56-game hitting streak that still stands as the record (Courtesy of the George Bush Presidential Library and Museum; see page 69); Williams takes batting practice before the 1982 Red Sox old-timers game at Fenway Park (Courtesy of the Trust Collection; see page 36); Williams, seated, shakes hands with Tony Gwynn as Cal Ripken Jr. (Orioles, No. 8) stands by; other nominees for baseball's All-Century Team and then-current All-Stars wait to pay homage before the 1999 All-Star Game at Fenway Park (Courtesy of the Boston Red Sox; see page 82); Williams delivers his induction speech at the hall of fame on July 25, 1966 (Courtesy of the National Baseball Hall of Fame Library, Cooperstown, New York; see page 18); Williams's famous No. 9 is prominent at the 1984 Red Sox old-timers game (Courtesy of the Trust Collection).

On the Back Cover: From left to right:
Former teammates Jackie Jensen (left) and Bobby Doerr flank Williams at the Red Sox old-timers game in 1982 (Courtesy of the Trust Collection; see page 40); Williams shields the sun during a media session on Hall of Fame Day, July 29, 1985, in Cooperstown, New York (Courtesy of the Trust Collection); Ted swung his way into retirement by hitting a home run in his last at-bat in the major leagues on September 28, 1960 (Courtesy of the Boston Red Sox; see page 10).

IMAGES
of Modern America

TED WILLIAMS AND FRIENDS
1960–2002

To Kevin McGill —

I hope you'll enjoy the photos and written words on "The Greatest Hitter Who Ever Lived"

Thank you for your service!

Dick Trust

April 2015

Dick Trust

ARCADIA
PUBLISHING

Published by Arcadia Publishing
Charleston, South Carolina

Printed in the United States of America

Library of Congress Control Number: 2014946837

For all general information, please contact Arcadia Publishing:
Telephone 843-853-2070
Fax 843-853-0044
E-mail sales@arcadiapublishing.com
For customer service and orders:
Toll-Free 1-888-313-2665

Visit us on the Internet at www.arcadiapublishing.com

To the splendid Michael, Gary, Molly, and Diane.
You are in my lineup every day, rain or shine.

CONTENTS

ACKNOWLEDGMENTS

Like a good leadoff hitter, author Herb Crehan was first up in recommending that my collection of photographs of Ted Williams that I took during his post-baseball playing career be sent to Arcadia Publishing for consideration as the basis for a book about the Splendid Splinter's years after the drama of his last at-bat on September 28, 1960.

The photographs, which included many of Williams's baseball contemporaries, were embraced by Arcadia acquisitions editor Caitrin Cunningham. Finding other photographs to complement the ones I had taken led me to Pat Kelly at the National Baseball Hall of Fame and Museum in Cooperstown, New York; to Gail Morchower and Don Keller at the International Game Fish Association Hall of Fame in Dania Beach, Florida; and to Mary Finch at the George Bush Presidential Library in College Station, Texas.

Dr. Jim Lonborg, Ted Lepcio, Sam and Connie Mele, Boo Ferriss, and Walpole Joe Morgan helped me in the earliest stages. Richard Johnson, Bill Nowlin, Saul Wisnia, Sarah Coffin, Mike Fine, Brian Noble, Heather Lyon, and Matt Thomay saved many a day. Jack Donovan serves ice cream, but the cherry on top was his contribution of photographs.

Unless otherwise noted, all images appear courtesy of the author.

Don Fredericks, Joe LoRusso, Rich Rossetti, Don Prohovich, Fred Brown, Dave Levine, Tina Murphy, and Jeff Friedman provided tales of the Ted Williams Baseball Camp.

My late parents, Etta and Joseph, made certain that food from the fridge and love from the heart nourished me. I love my sister Lorraine despite her "tummy tickle" tortures. I revel in my sportswriting career that has touched six decades, the foundation of which was laid by my father's stories of those magical men who played big league baseball at or soon after the dawn of the 20th century. Three Finger Brown anyone? Anyone?

My vote for MVE (Most Valuable Editor) goes to Tim Sumerel of Arcadia Publishing. He is relentlessly thorough, unquestionably professional, the best editor a writer could ever imagine.

As for my written and photographic coverage of Ted Williams, he never objected to my snapping his picture endlessly: at old-timers games, at Cooperstown, or his standing or sitting patiently as I clicked. For some interviews, he would sit for 20 or more minutes. For that I tip my cap to Ted Williams—the greatest sitter who ever lived.

Last, I bow to Ed Neiterman, an elegant man of letters who at the 11th hour—more like 11:59—delivered the equivalent of a walk-off home run. Just the right finish. Thank you, Ed. Thank you, Ted.

INTRODUCTION

Ted Williams had one goal. As he put it, "When I walk down the street, I want folks to say, 'There goes Ted Williams, the greatest hitter who ever lived.' "

With the highest lifetime batting average (.344) of any major league baseball player of the post-1920, dead-ball era, third-most home runs (521) when he retired in 1960, and best on-base percentage (.482) in the history of the game, perhaps the Splendid Splinter met his goal. And these are only a fraction of his hall of fame statistics.

The first time I met Ted Williams, he was as Splendid a Splinter as the legend suggested. It was the summer of 1956, four years before he would retire as an active player, and I, not yet into my teens, was ready with an autograph book. The tall, handsome man approached jauntily, wearing a powder blue V-neck sweater over a shirt open at the collar and chino slacks.

It was at the back of the Somerset, the Boston hotel where Ted lived during the baseball season. The Red Sox slugger was walking to the garage to pick up his car for the short drive to Fenway Park.

I intercepted him, pen and autograph book outstretched.

"Can I please have your autograph?"

Without a word, Ted took the book, held it low against his right thigh, and penned his distinctive signature. I thanked him, and he was off to his car and another day at the ballpark.

I was off on cloud nine. Number nine, the baseball hero of my boyhood, had signed my autograph book.

Now that I had him once, I hungered for more. There was no lack of objects to have him sign: baseballs, pictures, other autograph books. You name it, I wanted it signed.

One day, after several such wordless, but successful, encounters at the back of the Somerset, Ted was walking with a friend, headed for the garage. Ted saw me waiting, pen and baseball in hand. As he approached, he admonished, "This is the hundredth goddamn time. When is this gonna stop?"

He wasn't angry, though. He reached out to me, shaking his head in mock disgust, and smiled. He took the pen, signed the ball, and moved to his car. No matter what he ever said, he never refused to sign. As a child, I got the Kid's autograph on one thing or another 17 times.

On one occasion at the players' parking lot at Fenway Park, I was there with an autograph book as Ted got out of his car and made his way toward the player entrance. I extended my book through the fence and, spying the longtime security guard, Tim Lynch, Ted bellowed: "See this kid? He's here *every* day."

No matter. Ted signed. No problem.

It was easy to adore Theodore Samuel Williams if you were a Boston boy growing up in the 1950s. He was electric. The good looks, the loping stride, the home runs—oh, those long, high-arc home runs—majestic clouts almost all of them. If you were listening to a Curt Gowdy broadcast of one of Ted's 521 round-trippers, you were likely to hear, "There's a high drive to deep right field . . . that ball is . . . going . . . going . . . gone . . . a home run."

Many Red Sox fans in the 1950s would not wait for the final out before leaving the park, unless Ted Williams was due up. They would stay until the seventh or eighth inning—ninth if they had to—awaiting Ted's last at-bat of the game. Then they would stream out of Fenway. The Sox did not field great teams in the late 1950s, and late-inning comebacks were neither anticipated nor frequent. It was safe to leave after Ted's at-bat.

Of course, I would stay till the bitter end. There were autographs to gather in the parking lot afterwards.

Ted's nasty, epic spats with some "knights of the keyboard" (as he had dubbed sportswriters) had faded into Boston newspaper lore by the time I joined the knights. Excluding his four-year stint as manager of the Washington Senators/Texas Rangers franchise, Ted's visits to town in his retirement were infrequent, generally limited to Jimmy Fund activities and, later, to old-timers games and other events ceremonial. He had mellowed and accommodated the media more graciously.

Granted, he was loud, a room easily taken over by his booming voice and larger-than-life presence. Known to have spit in the direction of writers in the press box, he was for that moment in time designated as the "Splendid Spitter." Married and divorced three times, with a son and two daughters largely on the periphery of his life until his waning years, he readily confessed that, while nearly unparalleled at hitting a baseball, he struck out as a husband and a parent. He peppered his language with rather inventive profanity. Yet in all of his complexities, he melted in a hospital room to a child with cancer, extravagant in his contributions to his beloved Jimmy Fund and its noble battle against the disease.

No other New England sports figure was cloaked in such mystery among the supposed hardened journalists. He was still electric, still created a buzz whenever he was in town. It was not unusual for writers (who were not on his "bad list") to ask Ted for autographs.

I vividly recall one interview among several I conducted with Ted. It was on September 26, 1971, when he was in his third and final season as manager of the lowly Senators. He was playful, winking, congenial. Mid-interview, I mentioned the Somerset and the autographs. He stopped, looked at me from behind the desk in the visitors clubhouse, studied my face with narrowed eyes, and said, "Was that you?" He remembered.

There was speculation that Ted might not manage when the Senators moved to Dallas–Fort Worth, Texas, in 1972 and would become the Texas Rangers. Ted was joyously evasive when I asked him if he would manage the Texas team, particularly in light of a story reporting that then–Dallas resident Mickey Mantle wanted the job. "I'm liable to be greeted at the airport in Dallas with signs, 'Mantle,' or 'Bring Back Stengel,'" Ted joshed. "That's got to leave an impression on you, doesn't it?"

For the record, Ted did manage in Texas, for one year (1972). Mickey Mantle never did. Neither did Casey Stengel.

After the interview, a man and his young son—the boy was maybe four or five and did not know who Ted Williams was—were outside the clubhouse, in the darkened corridor under the third-base grandstand. "Ted, would you take a picture with my boy?" the man asked.

Without hesitation, Ted obliged, saying, "Let's go into the stands. There's more light." Up the runway and into the park they went. Ted searched for the perfect spot from which to be photographed. He took hold of the boy, carried him up into a row of seats and crouched down, holding the boy close to him. "Smile at your daddy now," Ted coaxed the boy as both peered into the camera, Ted with a broad smile, his head cocked toward the little guy who still didn't know who Ted Williams was.

That little boy would be a man now and most assuredly knows who Ted Williams was.

One

TED'S LAST GAME

When Ted Williams played his last major league game September 28, 1960, only 10,454 fans were at Fenway Park. It was a cool, clammy Wednesday afternoon, and the Baltimore Orioles were the opposition in Boston's last home game of the season. It had already been announced that 1960 would be the Kid's final season in a career that began in 1939 and was interrupted twice by military service, 1943–1945 for World War II and 1952–1953 for the Korean War.

It turned out that this would be Ted's final game, but that was not made known until word reached the press box in mid-game. The 18-time all-star left fielder would not accompany the Red Sox to New York for their season-ending, three-game weekend series against the Yankees.

Jack Fisher was on the mound for the Orioles when Williams came to bat in the bottom of the eighth inning and settled into the left-hander's batter's box. On a 1-1 count, Ted swung and connected, sending the ball on a high arc toward right-center field and into the Red Sox bull pen. It was a home run, his 29th of the season and career number 521, in his last time at bat. Only Babe Ruth and Jimmie Foxx (both had played part of their careers for the Red Sox) had more home runs at that time, the Babe 714, Double X 534.

Ted rounded the bases, head down. He shook the hand of the next hitter, Jim Pagliaroni, as he crossed home plate and darted into the Red Sox dugout. The crowd urged Williams to come out for a curtain call. "We want Ted!" was heard several times over. Teammates, and even first base umpire John Rice, pleaded with him to step out and acknowledge the cheering. Maybe tip his cap. Nope, not doing it. Four minutes passed before play resumed.

Red Sox manager Mike Higgins sent Ted back out to his left field position in the top of the ninth inning, but Carroll Hardy replaced him immediately. Williams ran back to the dugout to more cheers. No response. As author John Updike would write in his *New Yorker* classic, "Hub Fans Bid Kid Adieu," "Gods do not answer letters." This god was now in the clubhouse, his playing days over, his postplaying career about to begin.

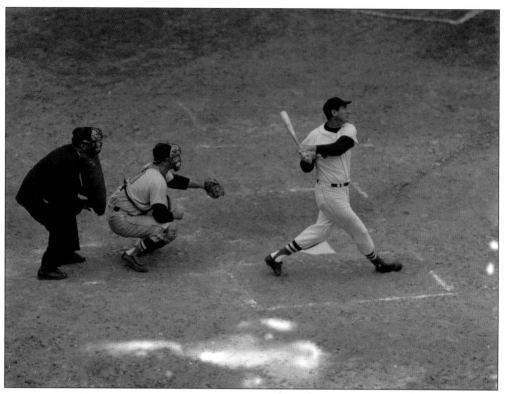

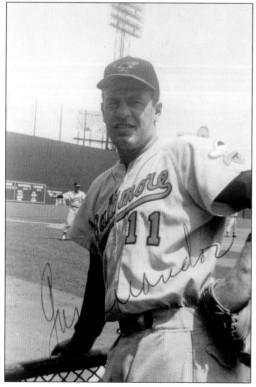

After taking the first pitch from Baltimore Orioles pitcher Jack Fisher for a ball, and a swing-and-a-miss on the next pitch, Ted swung and did not miss Fisher's third serve. Orioles catcher Gus Triandos and home plate umpire Eddie Hurley were eyewitnesses to history as Williams airmailed the baseball into the Red Sox bull pen, a home run in the last at-bat of his major league career, which began in 1939. (Courtesy of the Boston Red Sox.)

Gus Triandos was 30 years old and behind the plate for Baltimore on September 28, 1960, when Ted Williams, then 42, hit his 521st, and last, home run in the bottom of the eighth inning of a 5-4 Red Sox victory at Fenway Park. Triandos hit his 12th homer of the year, a two-run shot, in the second inning.

Billy Klaus was an infielder who played four of his 11 major league seasons with Ted Williams and the Red Sox (1955–1958), but he was an Oriole when Baltimore faced Boston in Ted's final game. Stationed for the majority of his 821 major league contests at shortstop, Klaus was of that rare breed who played for both the Boston Braves (1952) and Boston Red Sox.

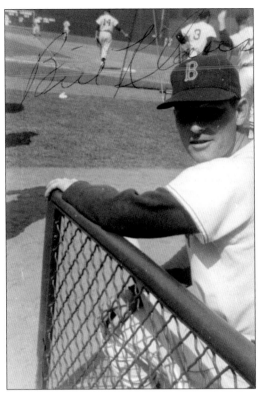

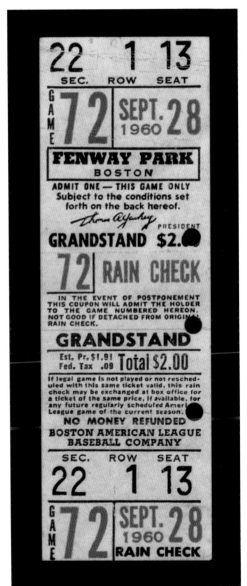

This is a grandstand ticket to Ted's last game, Section 22, Row 1, Seat 13. It cost $2 in 1960. In 2014, to sit in that same seat cost between $43 and $71, depending on the opponent (highest price paid for a game against the Yankees), time of year (lower in chilly April), day of the week, etc. (Courtesy of Uncle Sam Rounseville.)

Pictured here is the box score of Ted's last game.

Ted (right) shares a laugh with Carl "Yaz" Yastrzemski at spring training in 1978. Like Williams, Yaz spent his entire playing career with the Boston Red Sox (1961–1983). Ted twice was the American League's most valuable player, Yaz once. Ted twice won the triple crown (leading the league in batting average, home runs, and runs batted in), Yaz once. Both were first-ballot hall of famers. (Courtesy of the Sports Museum of New England.)

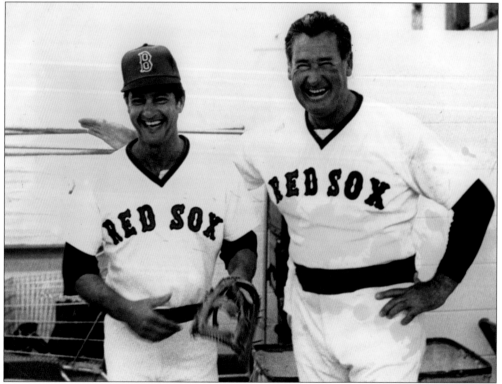

Ted (left) and Dick Stuart are pictured here at spring training in 1964. Stuart hit a total of 75 home runs in his two seasons (1963–1964) with the Red Sox, but his reputation as an error-prone first baseman earned him the dubious nicknames "Stonefingers" and "Doctor Strangeglove." (Courtesy of the Sports Museum of New England.)

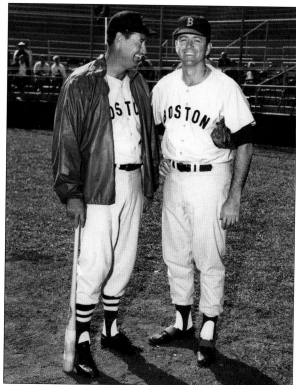

Erroll Garner (below, right) was a jazz pianist and one of Ted's favorite musicians. A fan of jazz, Ted frequently sat in on Garner's performances when he played Boston stages. Ted, at 6 feet 3 inches, towered over Garner, who was said to be 5 feet 2 inches and sat on a Manhattan telephone book so that he could properly strike the keyboard. Here, Ted gives Garner a tutorial in the fine art of handling a fishing rod and reel. (Courtesy of the Sports Museum of New England.)

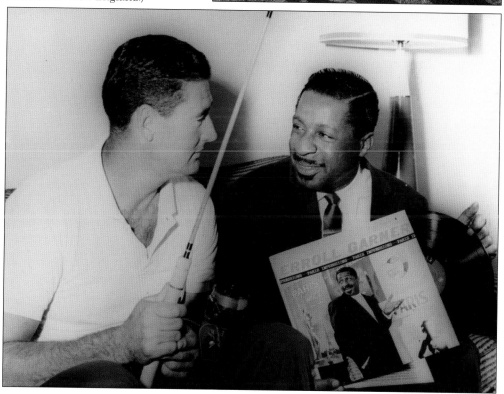

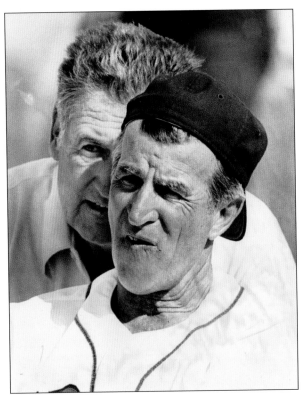

Johnny Pesky and Ted shared a lot of time together, such as this moment in spring training in 1986. Pesky was a "baseball lifer," starting in the game as a 12-year-old cleaning the bull pens for Portland of the Pacific Coast League in his native Oregon, eventually becoming a shortstop and teammate of Ted with the Red Sox. (Courtesy of the Boston Red Sox.)

Ted and Don Zimmer reminisce during spring training—two men with long careers in baseball and both with managerial experience. Here, Zimmer is manager of the Red Sox, a job he had from 1976 to 1980. (Courtesy of the *Patriot Ledger*.)

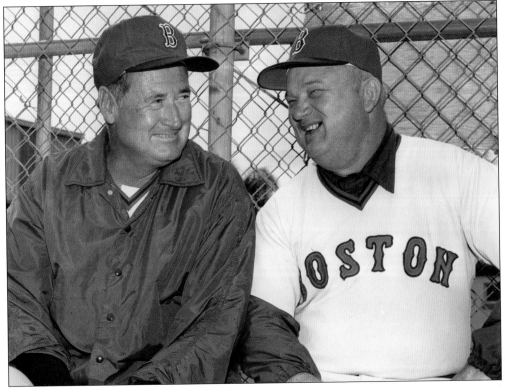

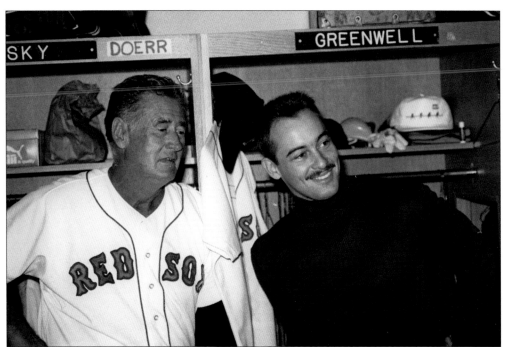

A pair of left fielders for the Red Sox talk business; Mike Greenwell (right) and Ted share their thoughts. Greenwell's entire big league career (1985–1996) was spent as a member of the Red Sox. Like Williams, a left-handed batter who threw as a righty, Greenwell had a sterling .303 lifetime batting average. A slashing singles-doubles-triples hitter, he still managed to hit 130 home runs. (Courtesy of Richard Johnson.)

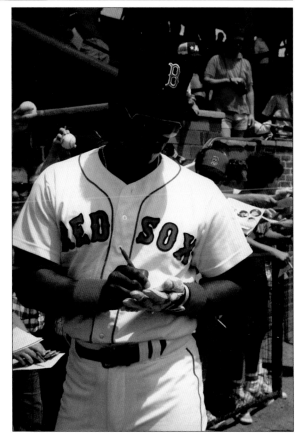

Jim Rice was another Red Sox left fielder who followed in the footsteps of Ted Williams. A power hitter from Anderson, South Carolina, Rice joined Ted and Carl Yastrzemski as a hall of famer (2009). Here, Rice signs autographs prior to the hall of fame game in Cooperstown, New York, on July 28, 1985.

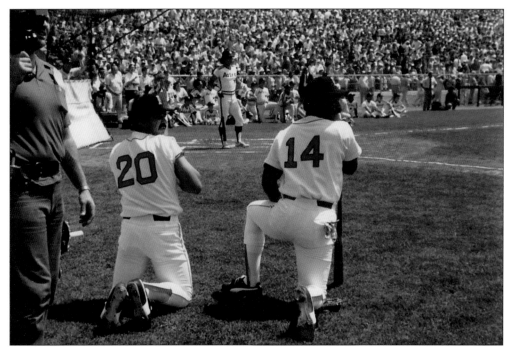

Pictured here is another look at Jim Rice, one of Ted's successful successors as a Red Sox left fielder. And like Ted, Carl Yastrzemski, and Mike Greenwell, Rice played his entire career, 1974–1989, in a Boston uniform. Rice (14) is pictured above with fellow Sox slugger Tony Armas (20) as they wait to hit in batting practice before the July 1985 Hall of Fame exhibition game in Cooperstown, New York. Below, Rice shows a sweet swing as he bangs a batting practice pitch down the third-base line.

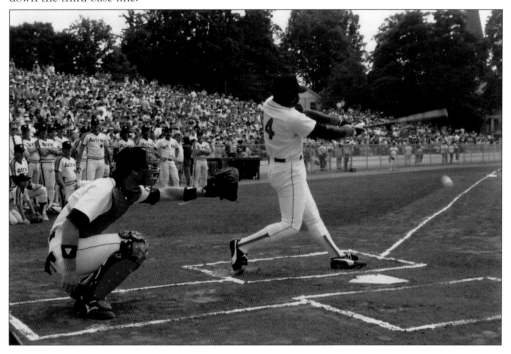

Two

MAN OF (ALL) THE PEOPLE

When Ted Williams was inducted into the National Baseball Hall of Fame in Cooperstown, New York, on July 25, 1966, it should have come as no surprise that his speech included a call to vote the great players from the Negro Leagues into the hall. It happened: Satchel Paige was the first inductee, in 1971, and many others have followed.

Dick Flavin knew early on that Ted was a champion of civil rights. A noted social commentator, television personality, and a public address announcer at Red Sox home games, Flavin likes to tell his audience when out on the speaking circuit about an incident in early 1960.

As the story goes, the Red Sox and Cleveland Indians conducted spring training in Arizona. At the end of camp, the teams flew together to New Orleans to play an exhibition game before heading north and opening the regular season.

When they arrived at the airport in New Orleans, one bus for each team awaited them, and one taxi. In 1960, New Orleans was still segregated. Each team had two black players: Pumpsie Green and Earl Wilson on the Red Sox, Jim "Mudcat" Grant and Vic Power on the Indians.

"The four black players got into their taxi and headed for the black hotel only to discover when they arrived that their luggage had been sent with the other players' bags to the white hotel," Flavin said. "Mudcat was deputized by the others to take the taxi cab to the white hotel and get their luggage. When he arrived at the white hotel . . . the bell captain said, 'No black guy—he didn't use that term; he used the 'n' word—is going to step inside this hotel.'

"Just then, Ted came around the corner. Mudcat told Williams of his predicament: 'The bell captain won't let me inside to pick up the luggage.' Ted said, 'Well, you *shouldn't* pick up the luggage. *He* should pick up the luggage.' Ted turned to the bell captain and said, 'Go get Mr. Grant's luggage and put it into the taxi cab for him.' Of course, it was Ted Williams talking, so the bigoted bell captain did as he was told."

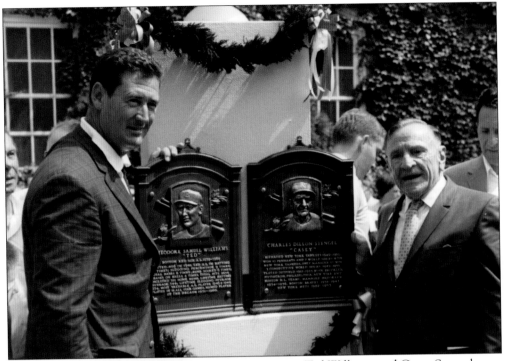

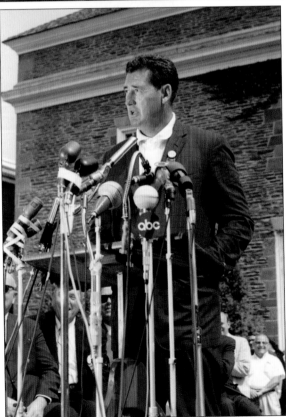

Ted Williams and Casey Stengel display their plaques after induction into the Baseball Hall of Fame in Cooperstown, New York, on July 25, 1966. Stengel batted a career .284 with a solid 60 home runs in the dead-ball era. He played 14 seasons (1912–1925) as a left-handed hitting outfielder for five National League teams (Brooklyn, Pittsburgh, Philadelphia, New York, and Boston). But he was elected for his managerial skills, leading the Yankees to 10 pennants and seven World Series titles in a run of 12 years (1949–1960). Williams told the assembled gathering that his enshrinement was "the greatest thrill of my life," but added, "I hope that one day Satchel Paige and Josh Gibson will be voted into the hall of fame as symbols of the great Negro players who are not here only because they weren't given the chance." (Both, courtesy of the National Baseball Hall of Fame Library, Cooperstown, New York.)

Ted Williams's hall of fame plaque lists his major statistical accomplishments: "Batted .406 in 1941. Led A.L. in batting 6 times; slugging percentage 9 times; total bases 6 times; runs scored 6 times; bases on balls 8 times. Total hits 2,654 included 521 home runs. Lifetime batting average .344; lifetime slugging average .634. Most Valuable A.L. Player 1946 & 1949. Played in 18 All Star games. Named Player of the Decade 1951–1960."

Satchel Paige delivered his induction speech at the National Baseball Hall of Fame in Cooperstown, New York, on August 9, 1971. A longtime star pitcher in the Negro Leagues, Leroy Robert "Satchel" Paige, on July 9, 1948, became the oldest man ever to debut in the major leagues (for Cleveland), at 42 years and two days old. He later pitched for the St. Louis Browns (1951–1953) and Kansas City Athletics (1965, one game).

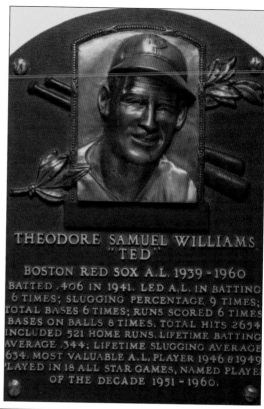

Infielder Elijah Jerry "Pumpsie" Green was the first African American to play for the Red Sox, the last major league team to integrate. Boston called him up from Triple-A Minneapolis in July 1959, and soon thereafter Ted Williams approached him. According to Herb Crehan in his book, *Red Sox Heroes of Yesteryear,* Williams said to Green, "Come on, Pumpsie, let's go warm up." They played catch before every game until Williams retired at the end of the 1960 season. Green remained with the Red Sox as a utility infielder and pinch hitter until his trade to the New York Mets in December 1962. After a brief stint as a Met and two-plus years back in the minors, he retired from pro ball in 1965, not long before his 32nd birthday. Green then entered the field of education, spending more than 30 years as a counselor and 20-plus as baseball coach at Berkeley (California) High School. Now 81 and retired, he sounds like a happy man: "All I had ever wanted to be was a professional ballplayer, and I was able to do it," Green told Crehan. "If I had it to do over, I wouldn't change a thing."

Frank Malzone was an eight-time American League all-star and three-time Gold Glove third baseman whose 12-year big league career included 11 seasons with the Red Sox (1955–1965) and one with the Los Angeles Angels (1966). His six-decade association with the Red Sox has included his years as a player (six with Ted as a teammate), scout, batting and field instructor and, at the time of this writing, player development consultant.

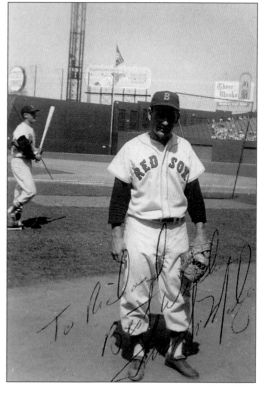

Ted surprised the baseball world when he accepted the job as manager of the Washington Senators on a five-year, $1.25 million contract beginning with the 1969 season. He was good at it, too, guiding the perennially sub-.500 club from the nation's capital to an 86-76 record, good for fourth place in the 10-team American League. With Ted at the helm, the Senators won 21 more games than the 1968 team (65-96) that finished last under then skipper Jim Lemon. For his efforts in improving many facets of the Senators' play, Williams was selected American League manager of the year in voting by sportswriters and broadcasters conducted by the Associated Press. In "Ted Shows How," a 1969 Topps card, Ted dispenses words of wisdom to Senators' first baseman Mike Epstein. (Topps® baseball cards used courtesy of The Topps Company, Inc.)

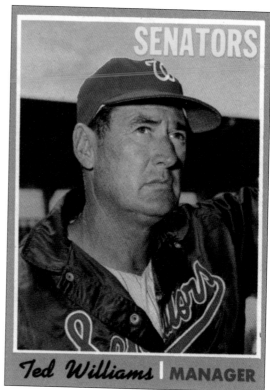

Ted Williams | **MANAGER**

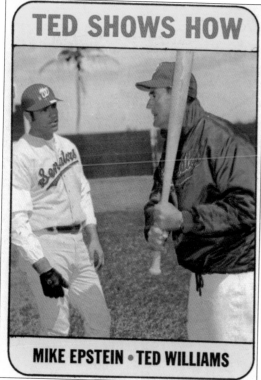

MIKE EPSTEIN • TED WILLIAMS

How to Get Household Help

the **Washingtonian**

75c MARCH 1970

The
Uncensored
Ted Williams

Jeane Dixon's
Curious
Charity
see page 51

The Senators'/Rangers' record worsened in each of the next three years with Williams as manager. The franchise had moved to Texas as the Rangers in 1972, and the club sank to 54-100, poorest in the majors. Ted decided not to return for a fifth season. Broadcaster Curt Gowdy noted in an interview with Williams, while he was still the manager of a team in decline, that the Kid could decompress by going fishing. "It could be one of the great salmon rivers in the world with a beautifully balanced fly rod, tying my own flies and catching Atlantic salmon," Ted says on the CD that accompanies the book *Ted Williams: The Pursuit of Perfection* by Bill Nowlin and Jim Prime, "I don't know what heaven's gonna be like—I may not get there—but this is the closest thing to heaven I can think of."

This photograph shows the library at the National Baseball Hall of Fame and Museum where induction ceremonies were conducted for many years. Now, they take place on the grounds outside of the Clark Sports Center, which is located on Susquehanna Avenue, just one mile south of the hall of fame.

22

Three

GOING CAMPING

Ted partnered with Al and Bernie Cassidy and Les Warburton in the Ted Williams Baseball Camp, which opened in 1958 in Lakeville, Massachusetts. The camp served thousands of boys from seven through their teenage years before closing in 1986. Some 250 to 300 campers would take part in weekly or multiweek sessions from late June to the third week in August.

Ted would spend at least one week per summer at the camp, some summers several weeks, and demonstrate what made him "the greatest hitter who ever lived."

Among the campers in the summer of 1962 was a recent Stoughton, Massachusetts, high school graduate, Don Fredericks, who bore a striking resemblance to a young Mickey Mantle. Fredericks, who 10 years later would begin a long and successful stint as high school and American Legion baseball coach in Braintree, Massachusetts, befriended Ted's first daughter, Barbara-Joyce (known more as Bobby-Jo), and was invited to Williams's Islamorada home in the Florida Keys for 10 days during Don's winter break in his freshman year at Springfield College.

One morning, Ted announced to Fredericks that they would be going fishing. "I don't know what we were fishing for," Fredericks said some 52 years later, "but he caught a fish and it was something big. He was only on an 8-pound test line using fly-fishing equipment on this huge fish and he reeled it for 45 minutes to an hour.

"He finally said, 'Bush (he called everyone "Bush"), gaff the fish.' I didn't know what was going on. I had told him I wasn't a fisherman. But I gaffed the fish and gaffed his line, too—broke it after all the hard work he had done. He was all over me with 'Bush this and Bush that,' all sorts of things.

"Well, we stayed there and he caught another one, reeled it in—I didn't gaff it this time—and we went back to shore. I stayed away from him and he yelled across the dock where he was going to have his picture taken with this fish—you could hear him from here to Christmas —'Come on, Bush, get in this. You're part of this sad story.' "

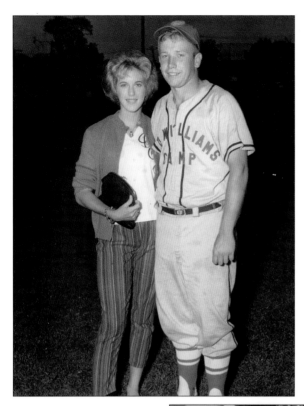

In the summer of 1962, Ted's daughter Bobby-Jo was 14 and Don Fredericks of Stoughton, Massachusetts, was a 17-year-old recent high school graduate and Mickey Mantle look-alike attending the Ted Williams Camp in Lakeville, Massachusetts. There, the youngsters met, dated, and became close friends for a year and a half. Then they went their separate ways and met briefly only once again. Bobby-Jo Williams Ferrell died of liver disease in 2010. (Courtesy of Don Fredericks.)

Don Fredericks, seen here on July 24, 2014, turned 70 on October 19 of the same year. He retired a little more than a decade before from a career in education in the Braintree, Massachusetts, school system. He coached baseball at Braintree High School for 20 years, winning the Division 1 state championship in his very first season. Ted Williams once told him that he was a good ballplayer but not good enough to turn pro. "Go into coaching," Ted urged him. Fredericks did. No regrets.

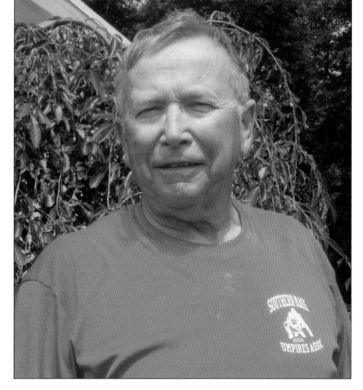

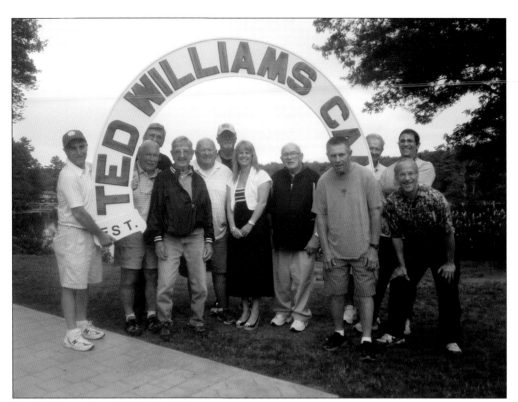

The 2014 reunion of the Ted Williams Baseball Camp alumni was held August 3 on the grounds of the since-closed facility in Lakeville, Massachusetts, located 40 miles south of Boston. Pictured here from left to right, they are camp alumni coordinator Joe LoRusso, Dave Piasecki, Don Prohovich (behind Piasecki), Bill Twomey, Earl Mathewson, Tim Taylor, Tina Murphy, Fred Brown, Marc Letendre, Frank Warrington (partially hidden behind sign), Rich Rossetti, and Dave Levine (front, hands on knees).

Joe LoRusso was in the batting cage, hitting some pitches and missing some others, when a booming voice rose up from behind him: "Keep your eye on the ball." LoRusso turned around. It was Ted Williams, frequently going one-on-one with campers with the goal of improving each batter. LoRusso spent six summers as a camper and counselor and five years as a coach.

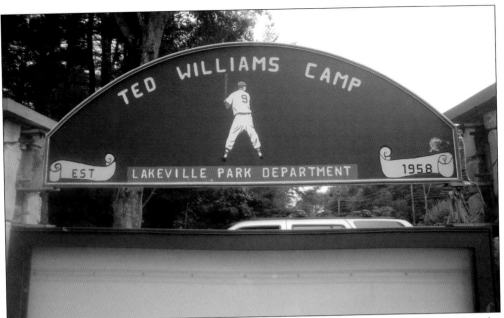

This was a familiar sign for those who attended the Ted Williams Baseball Camp before the Town of Lakeville, Massachusetts, bought the property following the camp's closing in 1986. Fred Brown was one camper-turned-coach who admired Ted greatly. "He signed my copy of his book, *The Science of Hitting*," Brown said. "He wrote: 'To Fred Brown, who loves baseball as much as I do—Ted Williams.' That will go in the box with me when I leave this world."

Rich Rossetti (right), here with his son Steve at the 2014 baseball camp reunion, was a camper when he celebrated his 17th birthday on August 7, 1978. He approached Ted, who was housed in the nurses' quarters, and asked him if he wanted a piece of his birthday cake. "No thanks, kid. I'm on a diet," the slugger told him. "But," Rossetti, a mechanical engineer, said, "I did get to meet him. That was cool."

26

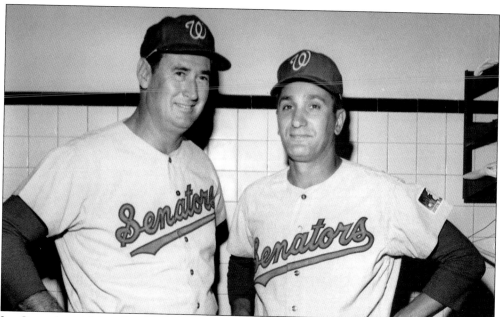

Joe Camacho (right) and Ted Williams worked side by side in the major leagues. Ted managed the Washington Senators (1969–1971) and moved to Texas when the Senators franchise became the Rangers in 1972. Camacho was Ted's bench coach for all four years. They met when Camacho was a senior instructor and director at Ted's baseball camp. When Ted left managing after the 1972 season, Camacho resumed his career as an educator (he was principal of New Bedford's Campbell Elementary School) and coach before his 1986 retirement. Below, former Williams camper James Camacho, left, and his father, Joe, right, pose with Ted and Ted's beloved Dalmatian, aptly named Slugger. This photograph was taken on a 1996 Father's Day visit at Williams's house in Citrus Hills, Florida, after Ted had recovered from two strokes. (Both, courtesy of the Camacho family.)

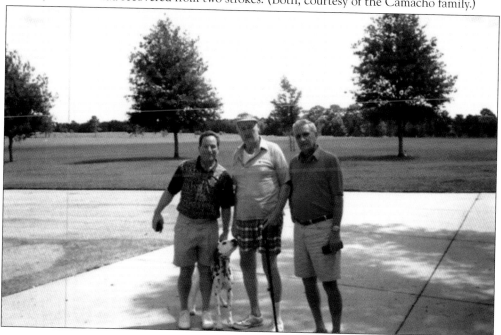

Joe Camacho's son James said he "used to talk to Ted on the phone all the time. He was always interested in your point of view. He was an inquisitor, always asking questions—he was the Socrates of baseball, I guess you could say. Question and answer, question and answer. He liked learning. I think that's what made him a great athlete. He was a beautiful person. I loved him. He was one of the nicest men I met in my father's life. He was a man. He had all kinds of different ranges of emotions. He was a good person. That doesn't mean he didn't have faults." (Courtesy of Bill Nowlins.)

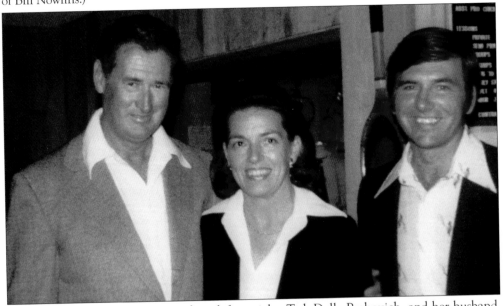

Taking time out at the camp are, from left to right, Ted, Dolly Prohovich, and her husband, Don Prohovich. Don signed a major league contract with the Chicago White Sox in the 1950s but never got beyond the minor league level. He was a shortstop, but future hall of famer Luis Aparicio manned the position, and Prohovich could not displace him. Prohovich then became a coach and clinician at the Williams camp; later he was an English teacher, coach, and athletic director at the high school level. (Courtesy of the Prohovich family.)

Four

THE JIMMY FUND

Ted Williams was considered the heart and soul of fundraising conducted by the Jimmy Fund of Dana-Farber Cancer Institute in Boston, Massachusetts, in its ongoing fight against cancer in children.

The Jimmy Fund has come a long way from Dr. Sidney Farber's one-room basement laboratory at Children's Hospital in Boston right after World War II. When the fund was founded in 1948, most children with cancer did not survive. Today, some forms of cancer maintain as high as a 90 percent rate of recovery, and Dana-Farber Cancer Institute has approximately 3,000 medical personnel, researchers, and others aggressively battling all forms of the disease.

The Variety Children's Charity of New England and the Boston Braves kick-started the 1948 fundraising efforts. A 12-year-old cancer patient, dubbed "Jimmy" to protect his privacy, was featured on a live national radio broadcast of *Truth or Consequences*, hosted by Ralph Edwards on May 22. Members of the Braves, Jimmy's favorite team, crowded into his hospital room amid the autographed bats, balls, jerseys and an official team uniform sized to fit the young patient that the Braves had brought. Jimmy was even invited to a doubleheader the next day, a twin bill in which the Braves swept the Cubs.

By fall 1948, more than $200,000 was raised for cancer research, and Dr. Farber's dream of establishing the nation's first center for fighting childhood cancers was well on its way to reality. The Jimmy Fund Building at the Children's Cancer Research Foundation opened in January 1952.

When the Braves announced in March 1953 that they were moving to Milwaukee, Wisconsin, Red Sox owner Tom Yawkey met with Braves owner Lou Perini, and Yawkey took the reins, adopting the Jimmy Fund as the official charity of the Boston Red Sox. By that time, Ted Williams was deeply committed to the cause. The Kid spent the rest of his life raising funds and making countless visits, most of them unpublicized, to youngsters in need.

In 1998, the original Jimmy resurfaced. He was Einar Gustafson, celebrating 50 years since the Jimmy Fund was founded and his recovery began. He and Ted met on a memorable and emotional occasion in 1999 and continued to raise awareness in the cause for a cure until Gustafson's death at 65 to a stroke on January 21, 2001, and Ted's passing on July 5, 2002.

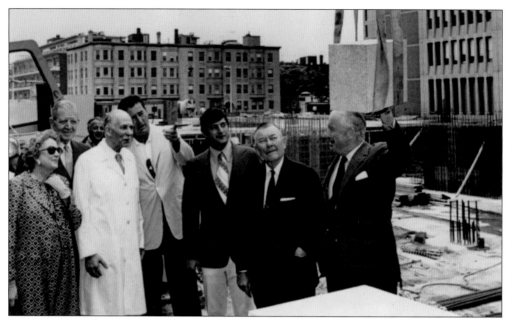

In 1971, Ted Williams (fourth from left, pointing something out to Dr. Sidney Farber) attended the cornerstone ceremony for the new Charles A. Dana Cancer Center at Dana-Farber Cancer Institute. Joining him and Dr. Farber for the event are, from left to right, Eleanor Dana, Walter Mann, fellow Red Sox great Carl Yastrzemski, Red Sox owner Thomas Yawkey, and Charles A. Dana Jr. (Courtesy of Dana-Farber Cancer Institute/The Jimmy Fund.)

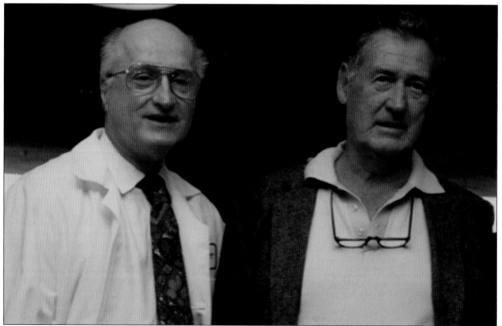

Dana-Farber physician-in-chief Emil Frei III, MD (left), is pictured here with Ted Williams at Dana-Farber in 1988, when Ted visited Boston to attend a 70th birthday celebration held in his honor at the Wang Center to benefit the Jimmy Fund. (Courtesy of Dana-Farber Cancer Institute/The Jimmy Fund.)

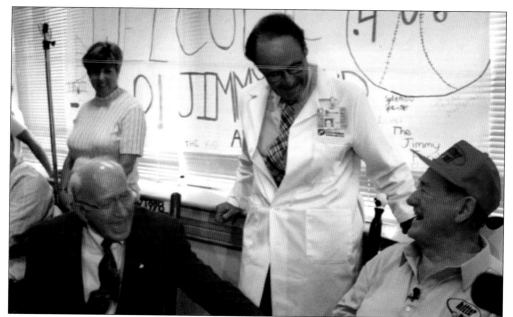

In 1999, Einar Gustafson (left) the original "Jimmy" for whom the Jimmy Fund was named, met for the first time with the charity's all-time greatest champion, Ted Williams (in cap). The two greeted each other and then many Dana-Farber patients and staff, starting with kids being treated in the Jimmy Fund Clinic. Also pictured is David G. Nathan, MD, Dana-Farber president (center). (Courtesy of Dana-Farber Cancer Institute/The Jimmy Fund.)

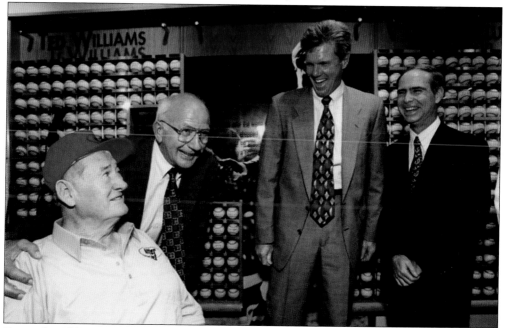

During his 1999 visit to Dana-Farber Cancer Institute, Ted Williams, far left, enjoys a laugh with, from left to right, Einar "Jimmy" Gustafson, Jimmy Fund chairman (and former Red Sox second baseman) Mike Andrews, and Dana-Farber oncologist Kenneth Anderson, MD. (Courtesy of Dana-Farber Cancer Institute/The Jimmy Fund.)

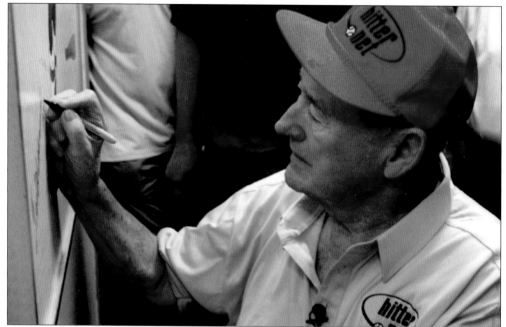

While visiting Dana-Farber Cancer Institute in 1999, Ted took a moment to autograph a wall in the pediatric clinic. Ted was gracious when it came to signing autographs. He signed for those of all ages but was especially pleased to offer his signature as a get-well gesture to kids in hospitals. (Courtesy of Dana-Farber Cancer Institute/The Jimmy Fund.)

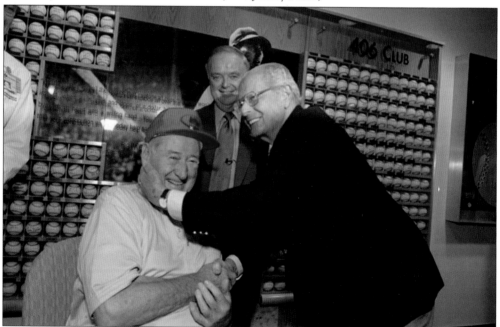

One of the best aspects of Ted Williams's 1999 trip to Boston was getting to see old friends like Dom DiMaggio—another great benefactor for Dana-Farber Cancer Institute who joined Ted in Dana-Farber's Jimmy Fund Red Sox gallery. Former Red Sox executive John Harrington, center, also was on hand. (Courtesy of Dana-Farber Cancer Institute/The Jimmy Fund.)

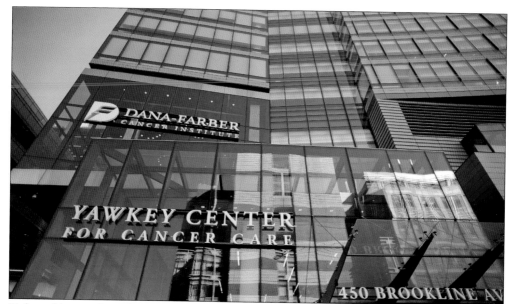

Ted would marvel at where cancer research has gone and what the money he raised has helped build. An example is Dana-Farber's Yawkey Center for Cancer Care. The glass structure stands 14 stories tall with 275,000 square feet of clinical space and seven underground levels of parking. The building is named to honor the late Tom and Jean Yawkey "in thanks to their foundation's leadership support," according to a Dana-Farber/Jimmy Fund website. (Courtesy of Dana-Farber Cancer Institute/The Jimmy Fund.)

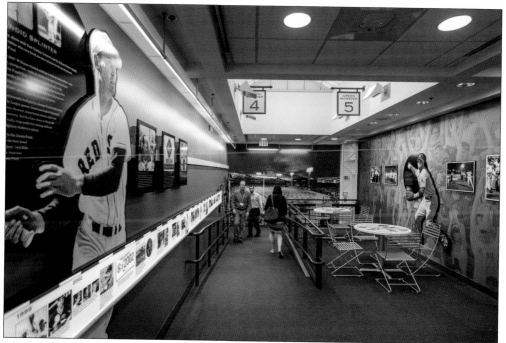

The new Boston Red Sox Jimmy Fund Gallery, opened in 2014, features a time line tracing the Jimmy Fund–Red Sox bond, the longest alliance ever between a professional sports team and charity in North America. (Courtesy of Dana-Farber Cancer Institute/The Jimmy Fund.)

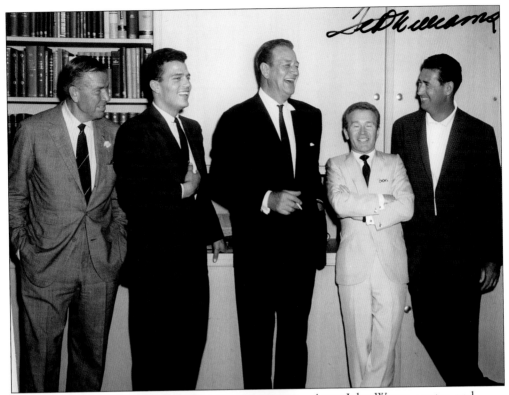

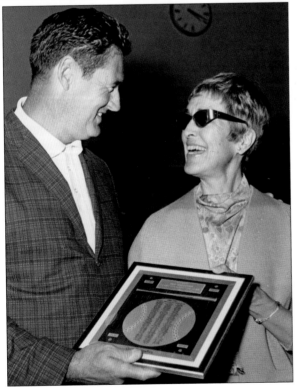

Actor John Wayne, center, and Ted Williams, far right, met for the first time on June 26, 1962, in Dr. Sidney Farber's office in the Jimmy Fund Building. They met after the filming of the African safari movie *Hatari!*, which stars Bruce Cabot (far left), Wayne, and Red Buttons (fourth from left). John Wayne's son Patrick is second from left. In the photograph at left, Red Sox owner Tom Yawkey's wife, Jean, presents Ted with a plaque listing many of the friends and dignitaries who contributed to a Jimmy Fund drive following Williams's hall of fame induction in 1966. (Both, courtesy of Dana-Farber Cancer Institute/The Jimmy Fund.)

Five

OLD-TIMERS GAMES

Red Sox old-timers games were in vogue at Fenway Park during the 1980s, with appearances by familiar players of the past putting on shows of nostalgia. In each of those exhibitions, the main attraction was Ted Williams, whose charisma remained when he called it a career in September 1960.

No longer the gawky, 6-foot-3-inch 140-pound Splinter who left his native San Diego, California, in the 1930s, Ted with a paunch still had a bat with a punch that wowed the crowds even in old-timers games. The old ballpark would fill up to see what Ted Williams still had in his 60s.

Others materialized from the mythical cornfields of his era—Is this heaven? No, it's Fenway Park—and Ted Williams and friends put on quite a show.

Among those who flew in across time were Ted's fellow outfielders for part of the 1950s, right fielder Jackie Jensen and center fielder Jimmy Piersall. Hall of fame second baseman Bobby Doerr made the long haul from the Rogue River in Oregon. Boo Ferriss, standout pitcher on the 1946 pennant-winning team, came up from Cleveland, Mississippi. Clyde Vollmer, Billy Goodman, Walt Dropo, Jim Lonborg, Luis Tiant, Dick Radatz, Frank Malzone, Rico Petrocelli, Mike Andrews, Carl Yastrzemski, and Sam Mele put on uniforms.

Joe, Dom, and Vince—the DiMaggio brothers—took part in 1986. Warren Spahn, Bobby Thomson, Ralph Branca, and Mark Fidrych put smiles on the faces of the fans. Bobby Valentine—yes, *that* Bobby Valentine, of pre–Red Sox managerial days—was on the field.

They all had appeal, those old-timers. They were invited for a reason. But the real reason for having an old-timers game in Boston, at Fenway Park, was to bring back Teddy Ballgame. No one else could cause one to crane a neck in order to catch even a glimpse from somewhere deep in the faraway seats. No one else could trigger a thunderous roar from the crowd and a tingle down the spine like the Kid.

A crisp, creamy white uniform with "Red Sox" on the front and a "9" on the back was all it took.

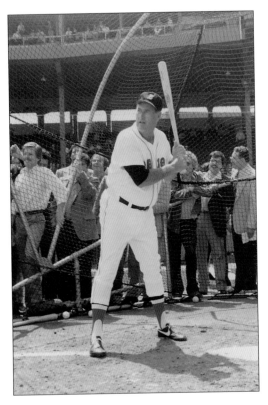

Ted shows his perfect swing and follow-through in this four-picture sequence of batting practice prior to the May 1, 1982, old-timers game at Fenway Park. A media mob hung out at the cage as Ted demonstrated the power and concentration that led to his .344 lifetime batting average and 521 home runs. Ted was 63 when this game was played and, judging from his approach at the plate here, it is easy to understand how he won his fifth American League batting title with a .388 average in 1957 at the age of 39, oldest ever for a batting champion at the time. He knew that if only six of his outs were hits that season, he would have batted .400 for a second time. Ted won batting championship number six the following season with a .328 average at age 40, and was the oldest until Barry Bonds won the National League batting title in 2004—Bonds was older by five weeks.

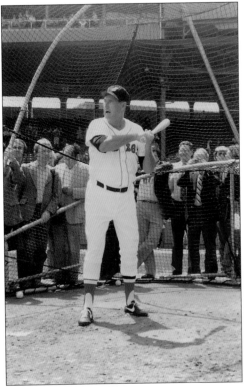

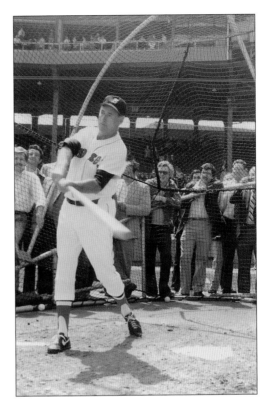

Talking to teammates, instructing young players in the minors when he was the Red Sox batting guru in spring training, and in the 1971 book *The Science of Hitting* that he wrote with author John Underwood, Ted stressed what sounded simple enough: "Pick a good pitch to hit." That went with his philosophy that hitting a round ball with a round bat squarely was the most difficult thing to do in sports.

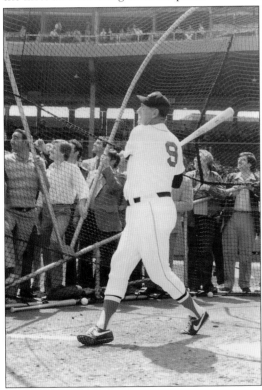

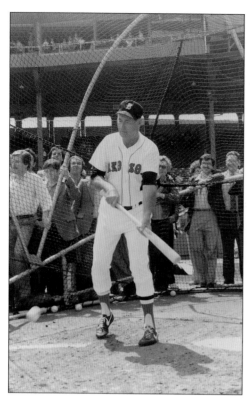

Ted's goal in life was not to have people say when they saw him walking down the street, "There goes Ted Williams, the greatest bunter who ever lived." But his showmanship shone through when he laid one down in the cage prior to the 1982 old-timers game, then tossed a ball back to the batting practice pitcher with the implied message, "Give me a good one to hit and I'll hit it out."

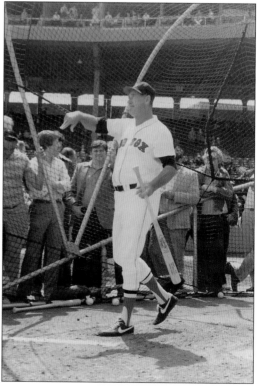

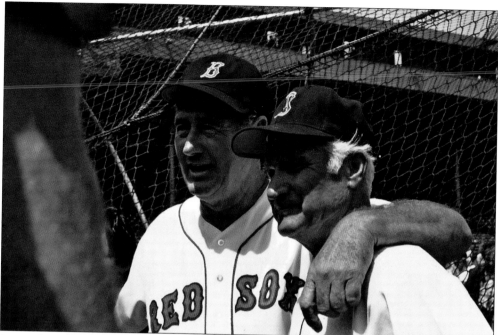

It was clear that Ted was as fond of Bobby Doerr the man as he was of Bobby Doerr the second baseman. They were teammates from 1939 until Doerr retired in 1951, but friends forever, even after Teddy Ballgame hung 'em up in 1960. Williams, Doerr, Dom DiMaggio, and Johnny Pesky were immortalized in David Halberstam's classic 2003 book, *The Teammates: A Portrait of a Friendship.*

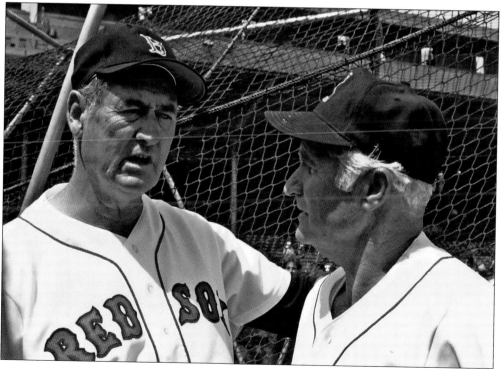

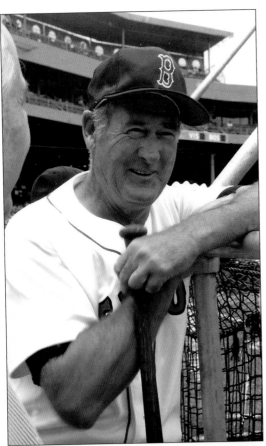

Ted wears a happy face here at the 1982 Red Sox old-timers game, the first in a series of such games that carried over into the 1990s. One reason for his smile was that he got a chance to mingle with former teammates and other Boston players who came on the scene after he retired in 1960. Two of those who played with him are (below, left) right fielder Jackie Jensen and (right) hall of fame second baseman Bobby Doerr. Jensen, who played seven seasons with the Red Sox and was the American League's most valuable player in 1958, died just two months after this photograph was taken. Doerr, who played his entire 13-year career with Boston, looked forward to his 97th birthday on April 7, 2015.

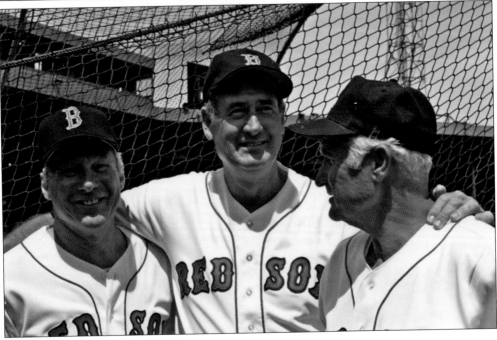

Clyde Vollmer was a 28-year-old journeyman outfielder when he came to the Red Sox in 1950. A Cincinnati native who would play 10 years in the majors and finish with a lifetime .251 batting average, Vollmer caught fire in Boston. He delivered big hits, home runs included, during his two-plus years with the Sox, earning the nickname "Dutch the Clutch." Of his 69 career home runs, 22 came in 1951 with Boston.

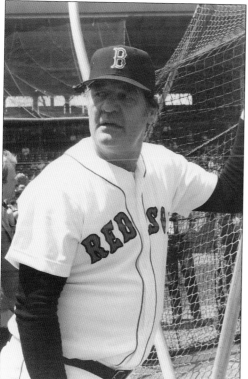

Walt Dropo, "the Moose from Moosup, Connecticut," a longball-hitting first baseman for the Red Sox, was American League rookie of the year in 1950. His Boston career was short-lived: on June 3, 1952, Dropo, a heartbroken Johnny Pesky, and three other players were traded to the Detroit Tigers for hall of fame third baseman George Kell, pitcher Dizzy Trout, and two others.

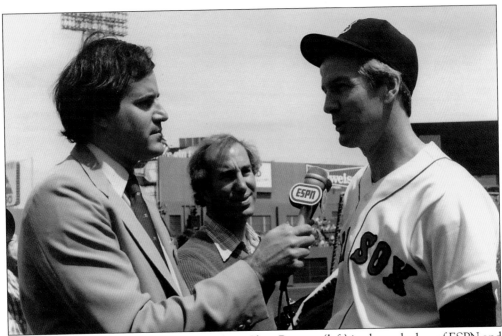

Jim Lonborg gets the interview treatment from Chris Berman (left) in the early days of ESPN and Boston radio station WBZ's Jonny Miller. Lonborg won the American League Cy Young Award in 1967 after his 22-9 record helped the Red Sox to the Impossible Dream pennant and a trip to the World Series against St. Louis. The Cardinals won in seven games.

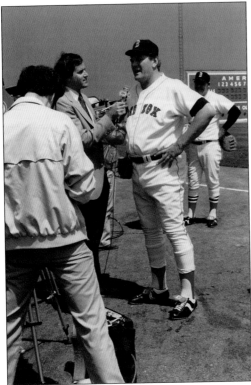

Dick Radatz speaks with ESPN's Chris Berman. Listed at 6 feet 6 inches and 230 pounds but appearing larger, the "Monster" was baseball's premier relief pitcher when he was at his peak. He blew away opponents of the Red Sox with a blazing fastball, celebrating victory with his trademark clasping of the hands high above his head. With Boston from 1962 until he was traded to Cleveland during the 1966 season, Radatz twice was named American League Fireman of the Year.

Billy Goodman enjoyed a 16-year major league career, playing all four infield positions (mostly at second base) and some in the outfield. A slender singles-and-doubles-hitting teammate of Ted Williams from 1947 until dealt to Baltimore in 1957, Goodman won the American League batting title in 1950 with a .354 average and finished his career at an even .300.

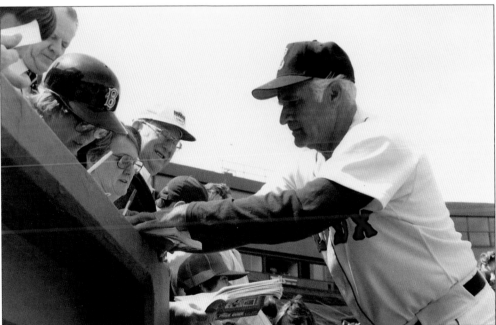

Bobby Doerr was already with the Red Sox for a little over one season (1937–1938) when Ted Williams came aboard in 1939. A slick-fielding .288 hitter with the power to belt 223 home runs in his 14 years in the majors (all with Boston), Doerr is shown here signing autographs before the 1982 old-timers game.

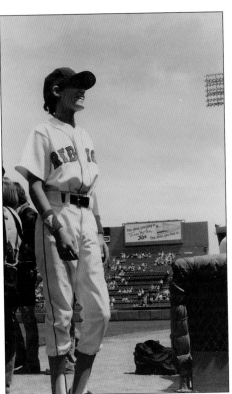

Ted's son, John-Henry Williams, was 13 and an honorary batboy in the 1982 old-timers game at Fenway Park. His younger sister, Claudia, 10 at the time, was in the stands that day and, as she writes in her 2014 memoir, *Ted Williams, My Father*, "I saw my father in a baseball uniform for the first and only time in my life."

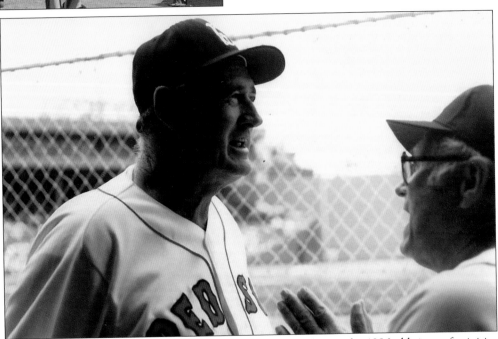

Ted, left, is engrossed in conversation with Paul Campbell during the 1986 old-timers festivities at Fenway Park. One of Ted's teammates in 1941–1942 and 1946, Campbell was a reserve first baseman who wrapped up his big league career with the Detroit Tigers (1948–1950). In 204 games, Campbell hit .255 with four home runs.

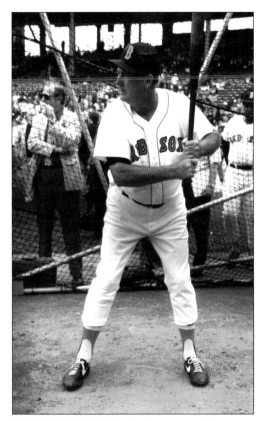

Ted strikes another perfect pose at the plate, bat cocked in readiness, his eye concentration unquestioned. Younger players, and those more experienced, would do well to study the stance and hope the results are positive, if not at the high level of those of the Splendid Splinter. Ted had quick wrists and was said to have 20/10 vision, which helped give him a wonderful sense of the strike zone. That is one reason he led the American League in walks eight times. Below, Dave "Boo" Ferriss, left, and Ted relive moments stretching back to the 1946 pennant-winning Red Sox. A right-handed pitcher, Ferriss went 25-6. Ted was the American League's most valuable player, hitting .342 with 38 home runs and 123 runs batted in. Ted would be MVP again in 1949, when Boston finished second, one game behind the Yankees.

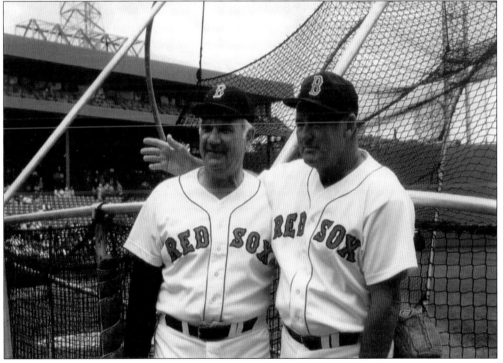

45

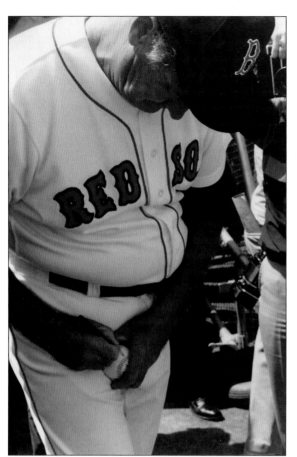

When Ted signed a baseball, it was almost always the same: He held the ball against his right thigh, checking to see if the sweet spot, that narrow band between the two wide arcs of stitching usually reserved for the stars of the game, was available. Then he affixed his signature in a beautifully crafted script that is so much more legible than the scribbles of many of today's stars. Despite the large number of autographs Ted signed that are available to collectors at live auctions and online, his signature is still in high demand.

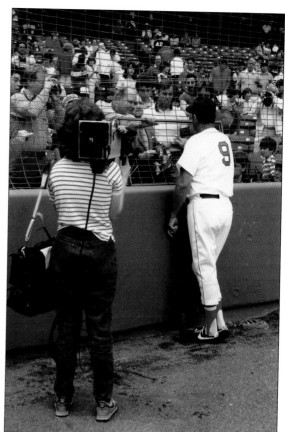

Ted turns from the batting cage and spots a longtime friend in the stands. He walks over, calls his friend to come down, and they talk for a few minutes as a television camera operator records even this moment in Ted's busy life. The fans in the stands also pay attention before Ted returns to the batting cage and begins to take mental notes on the swing each player exhibits in pregame mode.

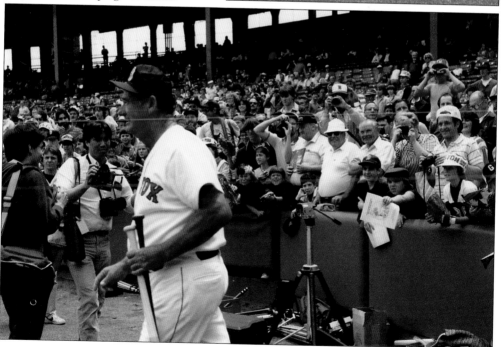

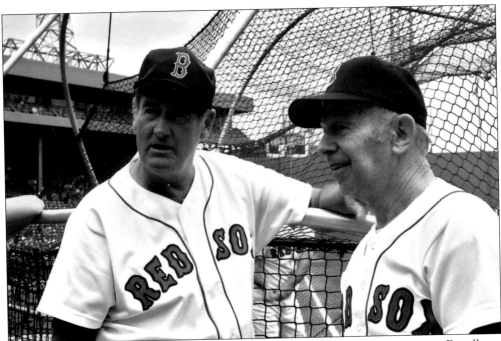

Rick Ferrell, right, and Ted share a conversation prior to the 1984 old-timers game. Ferrell was a catcher with 18 seasons in major league baseball, all in the American League. Inducted into the hall of fame later in 1984, Ferrell hit better than .300 five times in compiling a .281 lifetime batting average. Younger brother and teammate of pitcher Wes Ferrell (Red Sox 1934–1937; Boston Braves 1941), Rick caught for the Red Sox from 1933 to 1937. Below, Ted, left, leans in closer to share what appears to be another light moment with Ferrell.

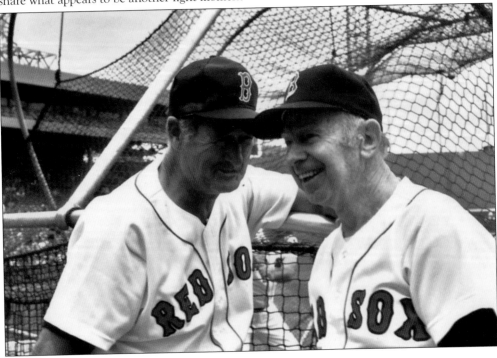

Jimmy Piersall (right) was one of the most exciting center fielders in Red Sox history, joining for much of the 1950s a starting outfield of Ted Williams in left and Jackie Jensen in right. Before becoming an established major leaguer of 17 years' duration, Piersall battled mental illness and was the subject of a Hollywood movie, *Fear Strikes Out*, starring Anthony Perkins. Cigar-smoking Cuban pitcher Luis Tiant (below) enjoyed a 19-year big league career, spending 1971–1978 with the Red Sox and going 2-0 in the 1975 World Series that Cincinnati's Big Red Machine won in seven games. Highly popular with the fans of Boston, Tiant, a right-hander, faced Ted in the 1984 old-timers game.

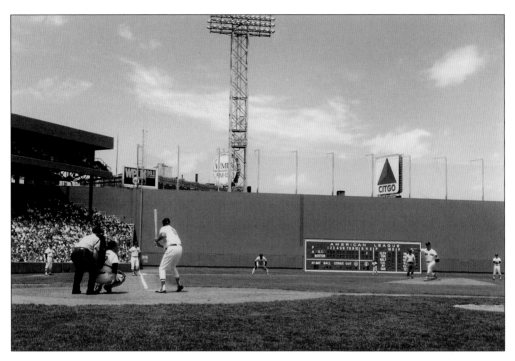

Ted waits for the pitch from righty Jim Lonborg and, below, makes contact against the 1967 American League Cy Young Award winner in the 1984 old-timers game, but he does not hit it out. Note that Fenway Park is two decades away from adding "Monster Seats" atop the 37-foot-high left field wall. Lonborg completed dental school after his 15-year major league baseball career ended in 1979 and still has his own private practice.

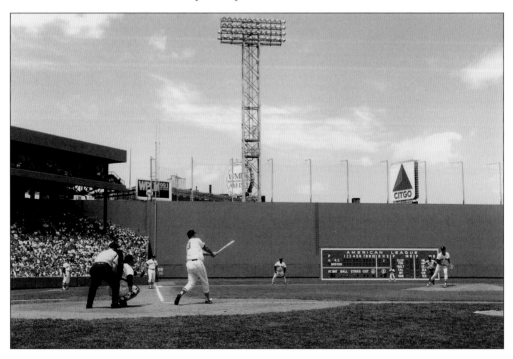

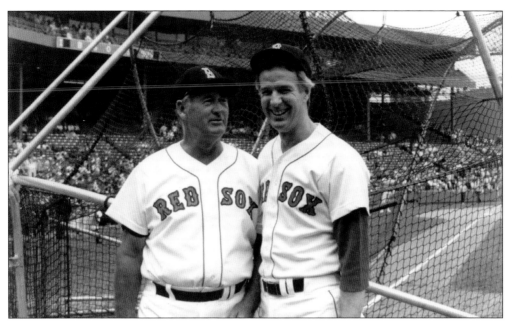

Ted and Jim Lonborg share their thoughts at an old-timers game. Lonborg's 15 years in the majors were split among Boston (1965–1971), Milwaukee (1972), and Philadelphia (1973–1979). Lonborg sustained a serious knee injury while skiing following the 1967 season and, although he never won 20 or more games in a single season again, he did finish his career 20 games over .500 (157-137) with a solid 3.86 earned run average. (Courtesy of Jim Lonborg.)

Smoky Joe Wood went 34-5 as a right-handed pitcher for the 1912 World Series–winning Red Sox. Here, Wood, at 94 years of age, is seated in a golf cart as he throws out the ceremonial first pitch to former Boston catcher Bob Montgomery, left, in the 1984 old-timers game.

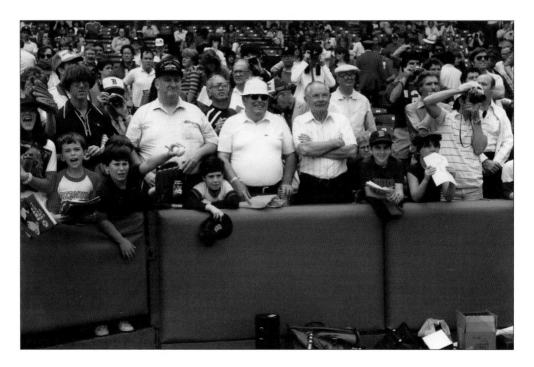

The crowd behind home plate for the 1984 old-timers game at Fenway Park is full, animated, and a good mix of young and older fans alike. The youngest fans are seeing ballplayers they had only heard or read about. For the older fans, it was the chance to see players from the past and perhaps relive some of their childhood. Below, Ted is inquisitive, always eager to hear what is on the other guy's mind. Here, the other guy is early-1950s Red Sox outfielder Clyde Vollmer.

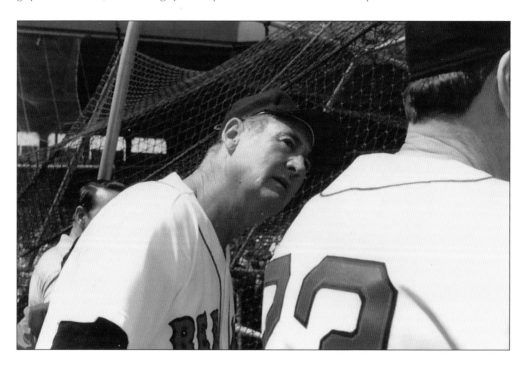

Ted spent some downtime at the batting cage prior to the start of the 1984 old-timers game. Downtime, yes, but not quiet time, as former teammates or otherwise admirers stopped by to reminisce or just say hello. Ted made conversation easily, and almost no subject was off-limits. Hitting a baseball and fishing were his favorite topics of discussion, and he would get quite passionate about each one. Much to the chagrin of his own manager, Ted would frequently go out of his way and offer batting tips to players on opposing teams.

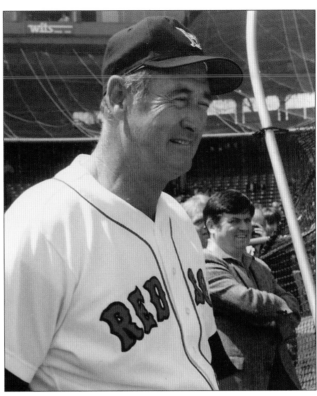

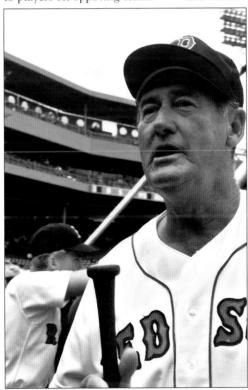

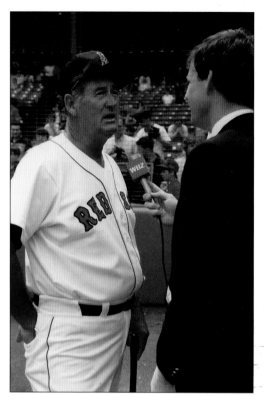

Whenever Ted was in town, it was certain that the media would take him aside and seek his opinions on whatever the hot-button topics of the day were. It was also a given that the fans in the stands would watch his every move, and cameras on and off the field would be trained on him. There was no other player in Boston baseball history with such magnetism.

Billy Goodman was traded by the Red Sox to Baltimore on June 14, 1957, for pitcher Mike Fornieles. Later that year, December 3, the Orioles dealt Goodman, pitcher Ray Moore, and outfielder Tito Francona to the Chicago White Sox for a package of four players that included hall of fame outfielder Larry Doby—the first black player in the American League (1947). Francona's son, Terry, won two World Series titles (2004 and 2007) as manager of the Red Sox (2004 through 2011).

John-Henry Williams is 17 here prior to the 1986 old-timers game at Fenway Park, where the Red Sox celebrated the 40th anniversary of the 1946 pennant-winning team. It was astonishing to many how much the son and the father looked alike. John-Henry would, as an adult, work with his father in the memorabilia business.

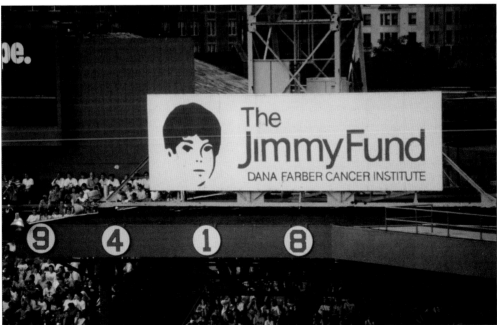

This iconic billboard atop Fenway Park's right field grandstand stood for years, bringing attention to the Jimmy Fund and its fight against childhood cancer. (Courtesy of Dana-Farber Cancer Institute/The Jimmy Fund.)

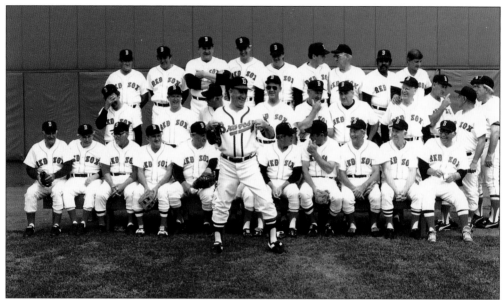

Warren Spahn clowns it up in front of the 1986 Red Sox old-timers before lining up with the team of opponents (below). The Red Sox team members, from left to right, are (first row) Bobby Doerr, Dom DiMaggio, Paul Campbell, Leon Culberson, Roy Partee, Johnny Pesky, George Metkovich, Charlie Wagner, Tom McBride, and Don Gutteridge; (second row) Rico Petrocelli, 1946 batboy Frank Kelley, Boo Ferriss, Joe Dobson, Clem Dreisewerd, Ed McGah, Earl Johnson, and Ted (talking with Frank Malzone and Bob Montgomery); (third row) Carroll Hardy, Darrell Brandon, Dick Radatz, Jim Lonborg, Jerry Moses, Mike Andrews, Mace Brown, Luis Tiant, and Carl Yastrzemski.

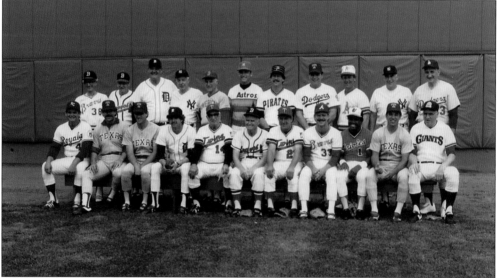

The opponents' team members, from left to right, are (first row) Steve Busby, Tom Robson, Tom Grieve, Mark Fidrych, Sam Mele, Tommy Holmes, Lee Stange, Tom House, Al Bumbry, Bobby Valentine, and Bobby Thomson; (second row) Vince DiMaggio, Warren Spahn, Walt Dropo, Joe DiMaggio, Eddie Yost, Art Howe, Tim Foli, Joe Ferguson, Rene Lachemann, Vic Raschi, and Ralph Branca.

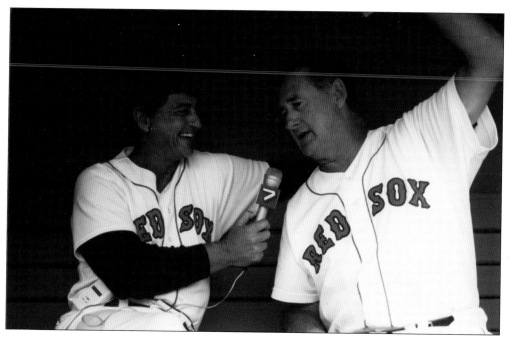

Left fielders compare notes as Carl Yastrzemski, working briefly for Boston television station Channel 7, interviews Ted during a break in the 1986 old-timers game festivities. Yaz would join Ted in the hall of fame in 1989, no surprise to Williams, who said he always knew Captain Carl had that special something. "I always said he was wound up like a spring when I first saw him," Ted said. "I think that's a great look for a kid: looking like he was just ready to go. He had that look. I saw him as a rookie coming in and I watched his whole career. He was a hell of a player."

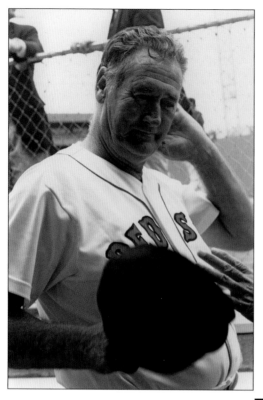

Legends get tired, too. So it appears as Ted Williams and Joe DiMaggio show signs of fatigue from the game and ceremonies during Old-Timers Day, May 17, 1986, at Fenway Park. Ted was a member of the 1946 American League pennant-winning Red Sox being honored on the 40th anniversary of that achievement. Ted was the league's most valuable player for the first time in 1946, and he won it again in 1949. The "Yankee Clipper," Joe DiMaggio, takes a break from all of the Old-Timers Day activities. A hall of famer like Ted, DiMaggio played fewer seasons, 13 to Ted's 19; hit fewer home runs, 361, to Ted's 521; had a lower lifetime batting average, .325, with Williams at .344; yet DiMaggio's 56-game hit streak in 1941 overshadowed Ted's .406 batting average in that Joe was named the American League's most valuable player.

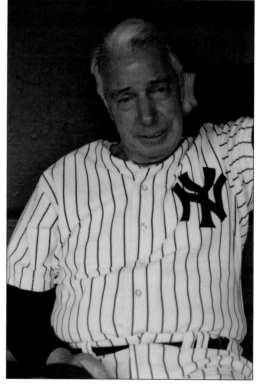

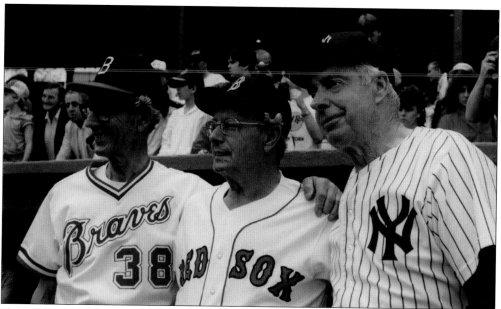

If the DiMaggio brothers—from left to right, Vince, Dom, and Joe, as seen on Old-Timers Day, May 17, 1986, in Boston—had carried out the wishes of their Italian immigrant parents, they would have been fishermen like their father, Joseph, and older brothers Thomas and Michael. But when Vince entered organized baseball in 1932 and came home with $1,500 he earned in the minors and laid it on the table, Joseph and their mother, Rosalina, were convinced. Baseball was all right.

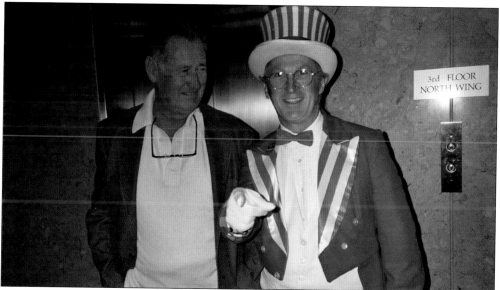

When Ted and Uncle Sam met at a Boston hotel before Ted Williams Day ceremonies, May 11, 1991, Ted quipped, "You got me once, you got me twice," referring to his military service in World War II and the Korean War. For the record, Leroy Lincoln Rounseville of Quincy, Massachusetts, changed his name legally to Uncle Sam Rounseville earlier in 1991. Among Sam's self-appointed duties are visiting elementary schools and making students aware of their responsibilities as American citizens. (Courtesy of Uncle Sam Rounseville.)

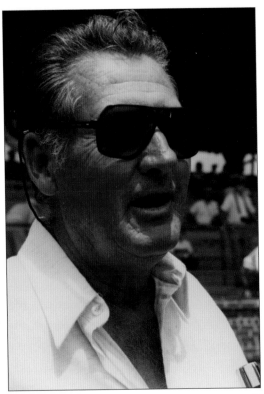

Ted had returned only once to the Baseball Hall of Fame since he and Casey Stengel were inducted in 1966. That was in 1980, when Williams accompanied Jean Yawkey for the enshrinement of her late husband, Tom, longtime owner of the Red Sox. Ted returned in 1985, when the inductees were Lou Brock, Enos Slaughter, Arky Vaughan, and Hoyt Wilhelm. The 1985 weekend carried extra significance in that then vice president George H.W. Bush attended the hall of fame exhibition game between the Red Sox and Houston Astros. Williams and Bush trained at the same Navy air station in Chapel Hill, North Carolina, during World War II, and the friendship they developed lasted decades. When Bush successfully ran for the presidency in 1988, Ted campaigned for him in New Hampshire.

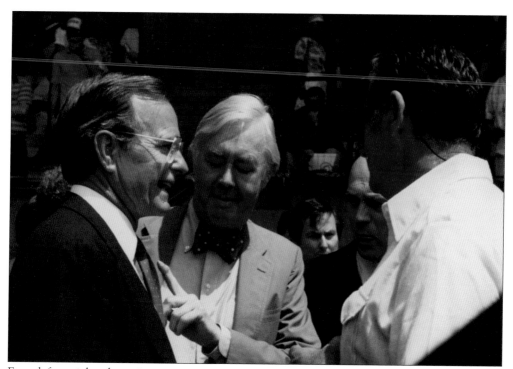

From left to right, then vice president George H.W. Bush, New York senator Daniel Patrick Moynihan, and Ted are engaged in an animated discussion at Doubleday Field in Cooperstown, New York. Perhaps it is about Bush's ceremonial first pitch he will toss before the Red Sox–Astros exhibition game. Bush was vice president under Ronald Reagan (1981–1989) and followed as the 41st president (1989–1993). Baseball is in Bush genes: the senior Bush played first base while at Yale University and in the first two College World Series; he was captain his senior year, 1948. Son George W. Bush played ball at Phillips Andover Academy (class of 1964), owned a piece of the Texas Rangers (1989–1994), and later served two terms as the 43rd president of the United States (2001–2009).

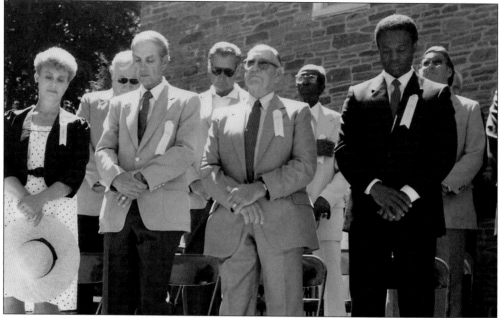

The late Arky Vaughan (represented by his daughter, Patricia Johnson, at left), and, from left to right, Hoyt Wilhelm, Enos Slaughter, and Lou Brock were the 1985 Baseball Hall of Fame inductees. Visible in the second row are past inductees, from left, Johnny Mize, Ted Williams, James "Cool Papa" Bell, and Brooks Robinson. Below, a collection of Baseball Hall of Famers lined up at Doubleday Field prior to the July 28, 1985, exhibition game in Cooperstown, New York, a picturesque village in rural upstate New York, located about 200 miles northwest of Manhattan. Pictured here are, from left to right, Ted Williams, Lefty Gomez, Hoyt Wilhelm, Enos Slaughter, Joe Sewell, Johnny Mize, Ralph Kiner, Billy Herman, Jocko Conlan, Happy Chandler, Lou Brock, and Robin Roberts.

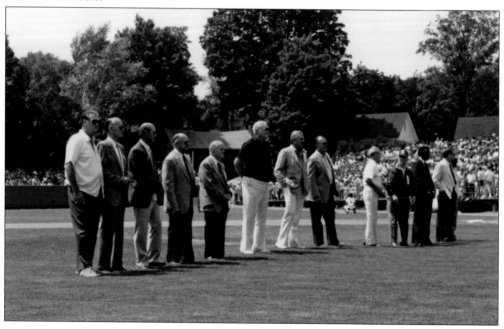

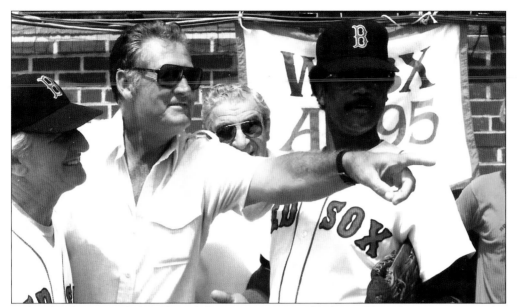

Ted makes his point before the exhibition game at Doubleday Field. Red Sox manager John McNamara is at left, team equipment manager Vince Orlando is behind Ted, and left fielder Jim Rice is at right. The American League's most valuable player in 1978, Rice was a lifetime .298 hitter with 382 home runs. He was inducted into the hall of fame in 2009.

Ted catches up with Red Sox right fielder Dwight Evans prior to the Boston-Houston hall of fame game. In the big leagues from 1972 to 1991, Evans spent the first 19 seasons with Boston and closed out with Baltimore. A career .272 hitter with 385 home runs, he is considered the best defensive right fielder in Red Sox history, complete with a rifle arm that gunned down many a runner.

Red Sox slugger Tony Armas met with Ted on Hall of Fame Weekend in July 1985, then met and satisfied his fans by signing autographs by the dozens. Armas spent four of his 14 big league seasons with Boston (1983–1986), achieving career highs in 1984 in home runs (43), runs batted in (123), doubles (29), at-bats (639), and strikeouts (156). A lifetime .252 hitter with 251 home runs, Armas is also pictured here getting in some batting practice before facing Houston in an exhibition game at Doubleday Field in Cooperstown, New York.

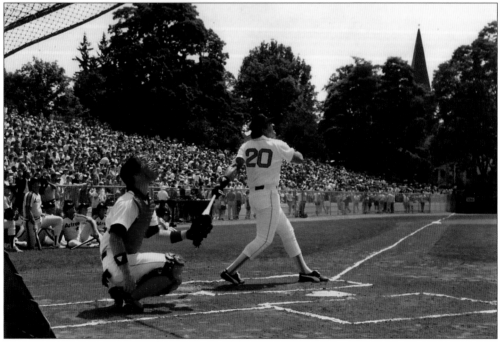

Wade Boggs, a five-time batting champion with a record seven 200-hit seasons (all consecutive), was at the hall of fame exhibition game in 1985. He was elected to the shrine in Cooperstown 20 years later. Boggs played for the Red Sox (1982–1992), Yankees (1993–1997), and Devil Rays (1998–1999) in an 18-year major league career that produced a .328 lifetime batting average and 3,010 hits.

The crowds at Doubleday Field are always swelled to capacity, 9,791, for the annual exhibition game that follows induction ceremonies in midsummer on Hall of Fame Weekend in Cooperstown, New York.

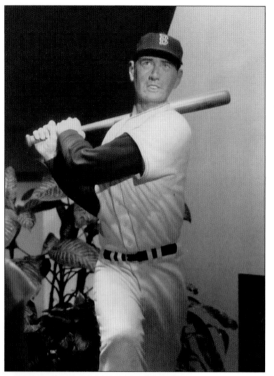

Armand LaMontagne was the sculptor, Ted Williams the subject, and this is the result—a stunning, life-size representation of the Splendid Splinter. Happily for fans of the Red Sox, and of Teddy Ballgame in particular, the wooden statue is one of the first sights upon entering the National Baseball Hall of Fame. Below, John-Henry Williams, Ted's only son, sees the sculpture of his father at the hall of fame and can hardly take his eyes off it.

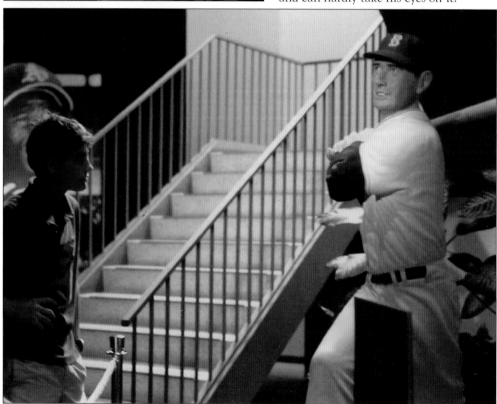

Six

HONOR ROLL

The 1980s and 1990s were important decades for Ted when it came to recognition for all he achieved, both on and off the baseball field. He was honored in many ways and in many places.

In 1984, his uniform No. 9 was retired by the Red Sox. Two years later, he threw out a first pitch in the World Series. He was twice honored by Pres. George Herbert Walker Bush. He had a street, highways, a tunnel, and athletic fields named in his honor. He was inducted into a fishing hall of fame.

He was named to the All-Century baseball team and was surrounded by other, adoring nominees in an unforgettable scene near the mound before the 1999 All-Star Game at Fenway Park was played as almost an afterthought. People remember a pack of legends descending upon *the legend*, but do they recall anything about the game beyond the strikeouts notched by the great pitcher Pedro Martinez? It was a night of nights, a show of shows, many players quoted as saying they wished the pregame meeting on the mound would never end.

Illness stalked the aged Ted Williams, but he still got out and about in the 1980s and 1990s, his presence in demand in all corners of the country. He turned up in so many cities and so many towns, someone would have thought that more than one Ted Williams inhabited the planet. Some were almost convinced that the Kid, the Splendid Splinter, and Teddy Ballgame were three distinct individuals.

He was grand marshal at an auto race in New Hampshire. He watched John Glenn, with whom he had flown on missions as Marines in Korea, soar into space from Cape Canaveral. Ted was honored with his image on a US postage stamp 10 years after he passed. (No living person may be pictured on a stamp issued by the US Postal Service.) The 2012 Major League All-Star series of four forever stamps also features Joe DiMaggio, Larry Doby, and Willie Stargell.

Even on a stamp, Ted went everywhere.

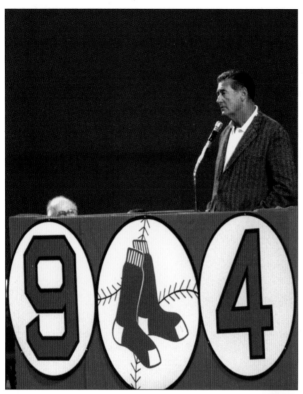

Ted's No. 9 and Joe Cronin's No. 4 became the first jerseys retired in a 1984 ceremony at Fenway Park. The numbers were placed on the facade in right field above Section 1. As of 2014, the facade featured eight retired numbers. In order of retirement, they are Williams (9), Cronin (4), Bobby Doerr (1), Carl Yastrzemski (8), Carlton Fisk (27), Johnny Pesky (6), Jim Rice (14), and Jackie Robinson (42). Robinson, a Brooklyn Dodger who broke major league baseball's color barrier, has had his number retired by all teams. Below, Ted threw out the ceremonial first pitch before the fifth game of the 1986 World Series. Note that he threw with his right hand. He played golf and tennis right-handed, and he signed autographs right-handed. He did most things from the right side except swing a baseball bat. (Both, courtesy of the Boston Red Sox.)

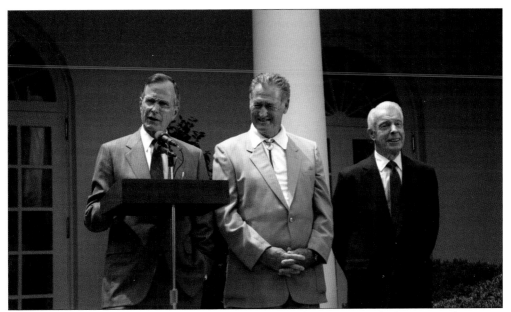

In 1991, Pres. George H.W. Bush paid tribute, on the 50th anniversary, to the historic performances of Ted and Joe DiMaggio in the 1941 baseball season. Ted batted .406; no one has reached .400 since. DiMaggio set a record that still stands by hitting safely in 56 consecutive games. The ceremony took place at the White House. In another 1991 ceremony, Ted received the Presidential Medal of Freedom, with First Lady Barbara Bush doing the honors. The Medal of Freedom is the highest award presented to an American civilian "for especially meritorious contribution to (1) the security or national interests of the United States, or (2) world peace, or (3) cultural or other significant public or private endeavors." (Both, courtesy of the George Bush Presidential Library and Museum.)

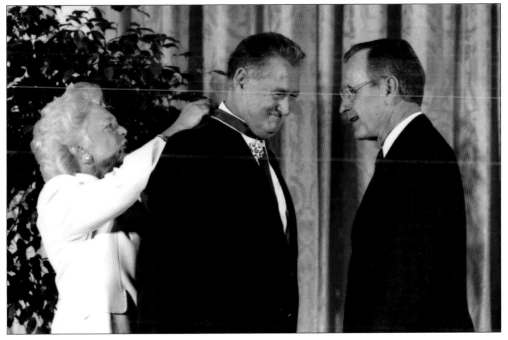

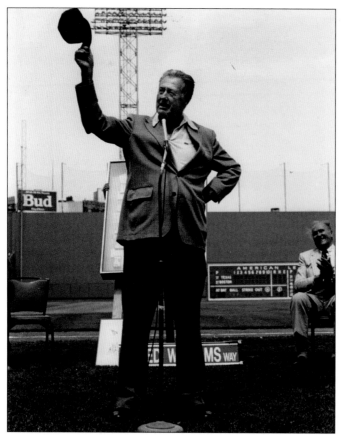

On May 11, 1991, Ted received the honor of having the portion of Lansdowne Street located behind Fenway Park's left field wall named Ted Williams Way. During his speech, he pulled out a Red Sox cap he had borrowed from a Boston player and waved it to the crowd for the first time since he was a rookie in 1939 and playing right field. Streets and highways in other parts of the country where he made an impact bear Ted's name, including the one pictured below in his native San Diego, California. (Left, courtesy of the Sports Museum of New England; below, courtesy of Bill Nowlin.)

Ted was honored yet again, this time in December 1995 with the opening of the Ted Williams Tunnel in Boston. It carries 1.6 miles of the final 2.3 miles of Interstate 90 under Boston Harbor, relieving traffic and making the trip to Logan International Airport in East Boston less stressful. (Courtesy of Richard Johnson/the Sports Museum of New England.)

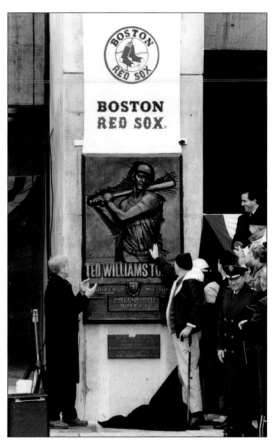

This sign was dedicated in 1990 at Ted Williams Field, named for the skinny teenager who in the early 1930s played at the neighborhood field then known as North Park playground in sunny San Diego, California. Every day, Ted swung and swung and swung his bat some more until the lights went off at 9:00 p.m. (Courtesy of Bill Nowlin.)

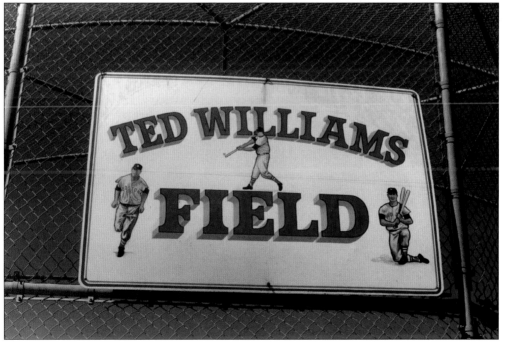

Barry Bonds visits the Splendid Splinter at the Ted Williams Museum and Hitters Hall of Fame in Hernando, Florida. Honoring what he and other elite batters achieved, it opened in February 1994, a few blocks from where Ted resided in his later years. The museum moved in 2006 to Tropicana Field, home to the Tampa Bay Rays, in St. Petersburg, Florida. Bonds hit the most career home runs, 762, and in a single season, 73, and won a record seven MVP awards, but his statistics are questioned because of alleged use of performance-enhancing substances. Below, former Negro Leagues star first baseman and manager Buck O'Neil came to Ted's museum. Like Ted, O'Neil was awarded a Presidential Medal of Freedom, but it was posthumously tendered by George W. Bush in December 2006, two months after O'Neil died at 94. (Both, courtesy of Bill Nowlin.)

Ted's son, John-Henry Williams (left), and Red Sox owner John W. Henry gather at the Ted Williams Museum and Hitters Hall of Fame in Hernando, Florida. Below, in another moment, Ted and former Red Sox hitter Brian Daubach hold a lighthearted conversation at the museum in Hernando. Daubach played eight big league seasons, including five with the Red Sox (1999–2002 and 2004). In 661 games as a first baseman, outfielder, and designated hitter, he had a career batting average of .259 with 93 home runs and 333 runs batted in. (Both, courtesy of Bill Nowlin.)

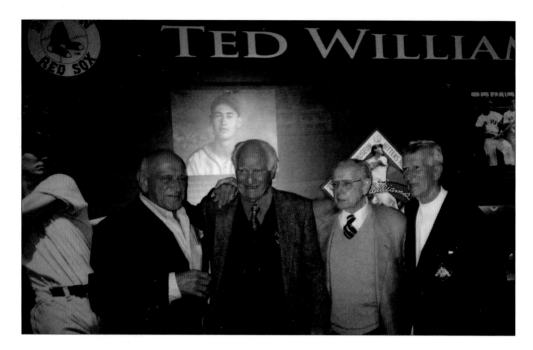

Enjoying a temporary exhibit of the Ted Williams Museum and Hitters Hall of Fame in Boston are former Red Sox stars, from left to right, Frank Malzone, Bobby Doerr, Dom DiMaggio, and Johnny Pesky. The special presentation of memorabilia debuted with a grand opening ceremony April 12, 2005, at the Top of the Hub in the Prudential Tower. Among the displays were a replica of Ted's locker and his home uniform, and photographs of Williams decorated the walls. (Both, courtesy of Jack Donovan.)

Ted Williams took the initiative of calling for Shoeless Joe Jackson's induction into the Baseball Hall of Fame in Cooperstown, prompting a symposium hosted by the Society for American Baseball Research (SABR) in Crystal River, Florida, May 29, 30, and 31, 1998. Jackson compiled the third-highest career batting average, .356, in major league history, behind Ty Cobb's .367 and Rogers Hornsby's .358. But his alleged association with the 1919 Black Sox Scandal led to commissioner Kenesaw Mountain Landis's lifetime ban from baseball for Jackson and seven other White Sox players on charges they took gamblers' money and threw the 1919 World Series against Cincinnati. Ted is seen here entering the Plantation Inn for his work at the symposium. (Both, courtesy of Bill Nowlin.)

Ted drives home a point at the 1998 symposium on Shoeless Joe Jackson. Author Jim Riley, who hosted the event, said in an interview for this book, "Ted's take was that, based on Shoeless Joe's talent and what he achieved as one of the great ballplayers of all time, he deserved to be in the hall of fame. He said Joe made one mistake: He took the money. But he regretted it and tried to give it back. And Ted thought Joe had played his best in the World Series." (Jackson had the highest composite batting average, .375, of any player in the series, won by Cincinnati, 5 games to 3.) In the photograph below, Ted listens to a presentation by attorney Lewis Hegeman. (Both, courtesy of Bill Nowlin.)

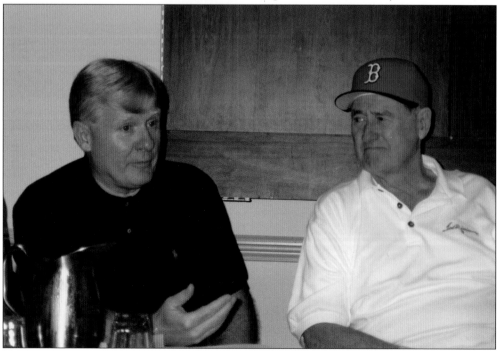

A classic, chiseled look of the Splendid Splinter is captured by the keen eye of photographer Fred Keenan as Ted takes in some Red Sox action during a game in the 1960s. Ted's concentration was akin to the attention to detail he demonstrated while at bat. (Courtesy of the *Patriot Ledger.*)

Ted and shortstop Johnny Pesky were Red Sox teammates in 1942 and, after a stint in the military, were together again from the pennant-winning season of 1946 until Pesky's trade to Detroit on June 3, 1952. Pesky later returned to the Sox as a coach, manager, and broadcaster, and his uniform number 6 was retired in 2008. He died August 13, 2012. He was 93. (Courtesy of Johnny Pesky, reproduced in the book *Mr. Red Sox: The Johnny Pesky Story*, by Bill Nowlin.)

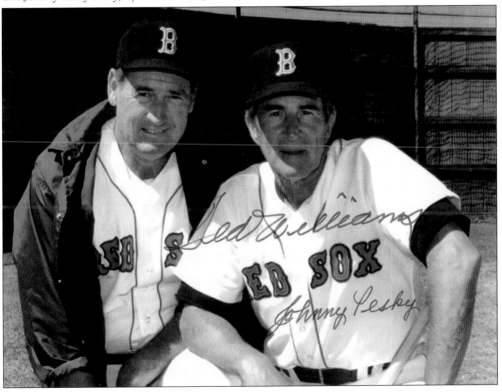

Ted was an individualist who did things his way, and his way did not require a traditional tied-and-knotted version of a necktie. A bow tie? No, thanks. He opted for the western string tie, which is about as formal as he ever got. (Courtesy of Bill Nowlin.)

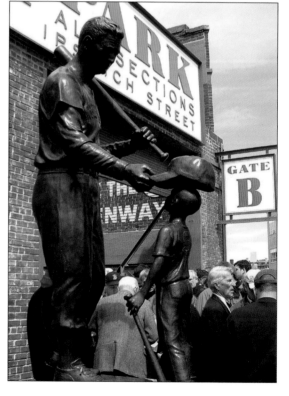

This statue of Ted Williams is 8 feet 6 inches tall, weighs 3,380 pounds, and stands outside Fenway Park's Gate B, behind the right-field line. Sculpted by Franc Talarico, it depicts Ted holding a bat on his left shoulder while he places his cap on the bald head of a child with cancer. (Courtesy of Saul Wisnia.)

Ted's lifelong passion aside from baseball was fishing. He angled for all varieties beyond tarpon, bonefish (shown in this photograph), and Atlantic salmon as chronicled in *Ted Williams: Fishing "The Big Three": Tarpon, Bonefish, Atlantic Salmon*, a 1982 book written by Ted and John Underwood. Ted caught bonefish and tarpon in the Florida Keys when he lived in Islamorada, and he went after salmon with his own tied flies in the Miramichi River in New Brunswick, Canada. For his expertise with rod and reel, he was inducted into the International Game Fish Association (IGFA) Hall of Fame in Dania Beach, Florida, in 2000. The great hall at the IGFA Hall of Fame and Museum makes a spectacular entry for visitors; its fascinating array of fish lures the looks of all who walk the hangar-like structure. (Both, courtesy of the IGFA Hall of Fame and Museum.)

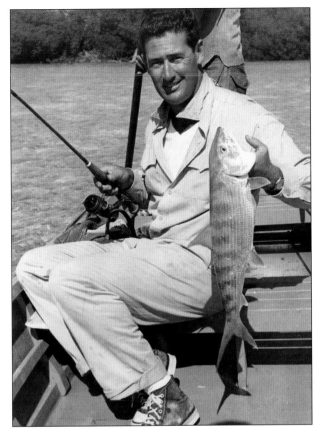

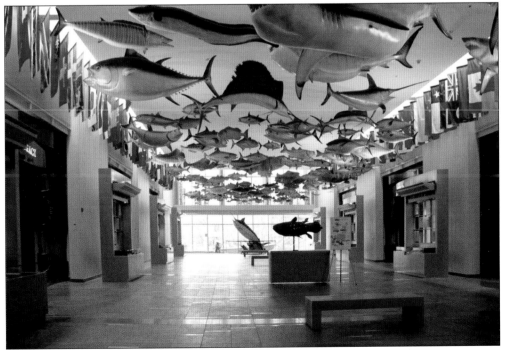

Ted and Atlantic salmon were synonymous when the Kid took off in summer and fall for virtual wilderness in pursuit of his favorite freshwater catch. A strict conservationist, Ted learned to release almost all of the fish he caught. Williams is shown here in a poster that is a watercolor/acrylic study for a sculpture by Armand LaMontagne on display in the Sports Museum of New England. The shot below of the salmon-rich Miramichi River in New Brunswick shows what attracted Ted (not pictured) to the region. The peaceful setting was ideal for a man who was in demand almost constantly by an adoring public. Ted's cabin contained a basement workbench at which he tied his own flies. (Left, courtesy of the Sports Museum of New England; below, courtesy of Bill Nowlin.)

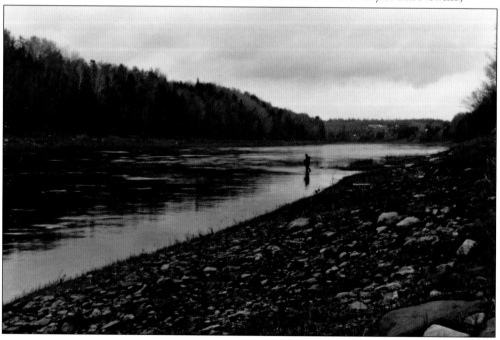

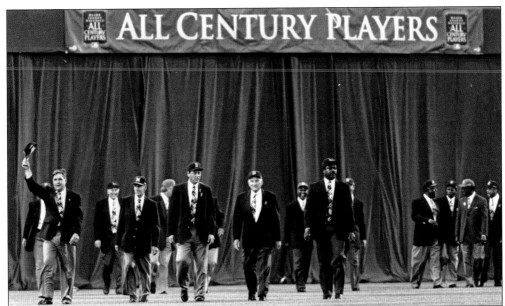

ALL CENTURY PLAYERS

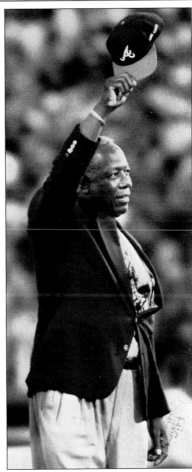

Nominees to the All-Century Team begin the walk from center field toward the infield and then on to the pitcher's mound during introductions prior to baseball's 1999 All-Star Game at Fenway Park in Boston on July 13. From left to right, they are 311-game-winning pitcher Tom Seaver, 16-time Gold Glove third baseman Brooks Robinson, 363-game-winning left-handed pitcher Warren Spahn, 10-time Gold Glove–winning third baseman and three-time NL MVP Mike Schmidt (partially visible), durable catcher Carlton Fisk, longball-hitting first baseman-outfielder Harmon Killebrew, acrobatic shortstop Ozzie Smith, home run–hitting first baseman Eddie Murray, Babe Ruth career home run record breaker Hank Aaron, base-stealers extraordinaire Rickey Henderson and Lou Brock, and "Mister October," Reggie Jackson. At right, Aaron is still considered by many the lifetime home run leader with 755, dismissing Barry Bonds's 762 as drug-enhanced. (Both, courtesy of Gary Higgins/the *Patriot Ledger*.)

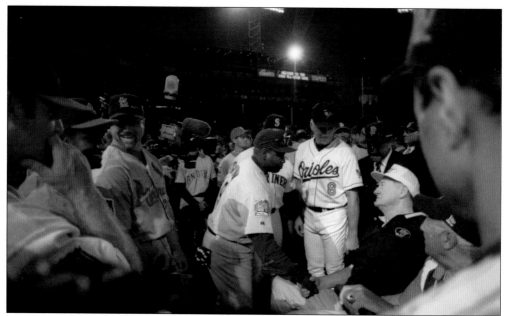

Ted was the center of the baseball universe on a night when all the stars came out. All-Century Team nominees and current all-stars converged in the area of the pitcher's mound to get a word with the 80-year-old Splendid Splinter. Seated in a golf cart on which he was driven in from his outfield entrance, he shakes hands with Tony Gwynn as Cal Ripken Jr. (Orioles, no. 8) stands by and others await their turns. (Courtesy of the Boston Red Sox.)

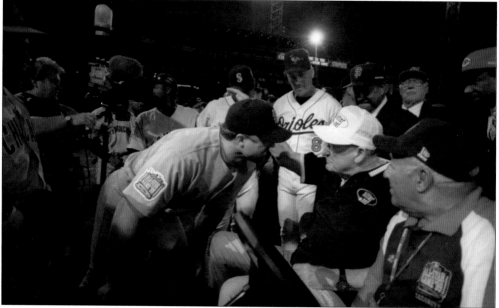

All-star Mark McGwire leans in to Ted, who asks the then Cardinals power hitter if he smelled wood burning when he fouled off a pitch. McGwire told Ted that he did, which put a smile on the face of Teddy Ballgame. "I did, too," Williams said. Tony Gwynn mentioned that Ted had asked him the same question, and Gwynn answered in the affirmative, as well. (Courtesy of the Boston Red Sox.)

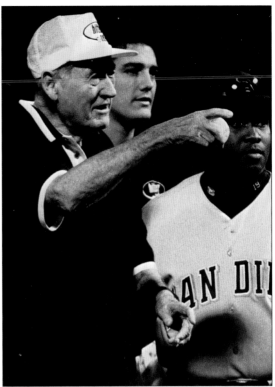

Standing in front of the pitcher's mound are, from left to right, Ted, his son John-Henry Williams, and San Diego Padres star Tony Gwynn as Ted gets set to uncork the ceremonial first pitch of the 1999 All-Star Game in Boston. Eyesight failing and unsteady on his feet, Ted does see former Red Sox catcher Carlton Fisk anticipating the toss. Just as Ted sizes up the distance he will need to cover with the pitch, Gwynn moves in and holds Williams securely. Ted then lets it fly and Fisk, in suit, tie, and Red Sox cap, catches a strike. (Both, courtesy of Gary Higgins/the *Patriot Ledger*.)

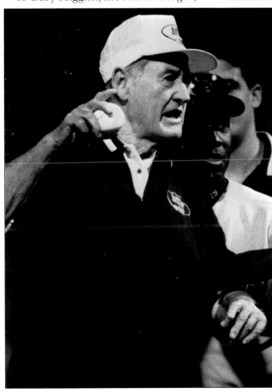

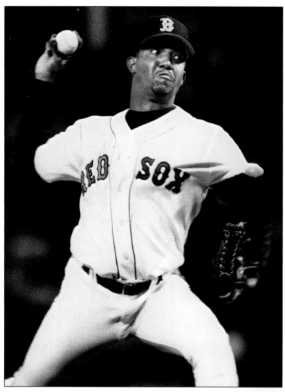

Starting pitcher Pedro Martinez shows the form that led to his striking out the first four batters and five of the six he faced in two innings of work, earning him the MVP award in the 1999 All-Star Game won by the American League, 4-1. Pictured below is then Red Sox shortstop Nomar Garciaparra, acknowledging the crowd as he leaves the All-Star Game. Having had a close relationship with Ted, Nomar, like his peers, reacted strongly to the public address announcer's plea for the stars to leave Ted's side and get the game under way. "They asked everyone to go to the dugout, and we're like, 'No, we're not,' " Garciaparra said. "It was like, 'Who cares about the game?' It was a special moment that no one expected. We didn't want it to end." (Both, courtesy of Gary Higgins/the *Patriot Ledger*.)

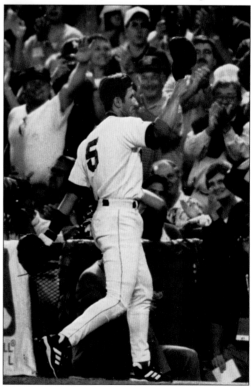

Seven

FAREWELL

The golden years? Ted never experienced them. Few people do. The Kid had three strokes, a broken hip, sleep apnea, open-heart surgery, and a pacemaker inserted. The love of his life, Louise Kaufman, died in 1993. He was on dialysis. He was weakened further by congestive heart failure. His once phenomenal vision had vanished; the public saw that at the 1999 All-Star Game. He required a walker, then a wheelchair. The lope was long gone. Hope was gone. Then he was gone. Born August 30, 1918, in San Diego, California, named Teddy Samuel Williams (he later changed his first name to Theodore), he died July 5, 2002, of cardiac arrest at Citrus Memorial Hospital in Inverness, Florida, near his home in Citrus Hills. He was 83.

His death saddened the sports world, but the grief was punctuated the next day by controversy. His children John-Henry and Claudia had his body placed in deep freeze at a cryogenics facility in Arizona. They insisted that cryogenics was their father's wish. Ted's older daughter, Barbara-Joyce Williams Ferrell, contended that her father wished to be cremated and his ashes spread across his beloved Florida Keys.

While the battle for Ted's remains raged on, Fenway Park hosted an all-day tribute to Ted's life on July 22, 2002. The park was open free of charge in the morning and afternoon for fans to express their emotions and view photographs and other memorabilia. A ticketed event was conducted in the evening and attended by a long list of dignitaries, including astronaut and senator John Glenn, many of Ted's teammates from the 1930s through the 1950s, and Red Sox players then recently retired or active at that time.

It was a night to celebrate the life of No. 9, the Kid, the Splendid Splinter, Teddy Ballgame. There went "Ted Williams, the greatest hitter who ever lived."

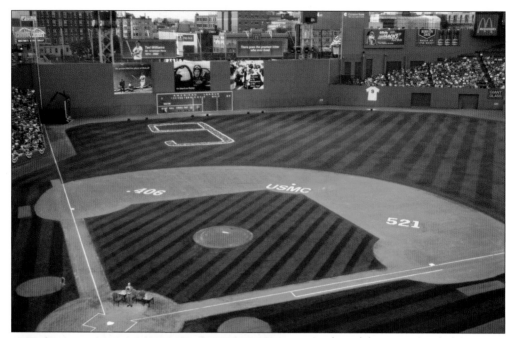

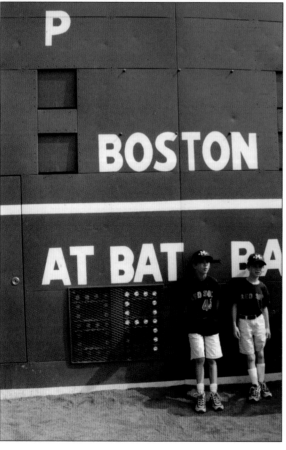

As the celebration of Ted's life is about to begin at Fenway Park on the evening of July 22, 2002, the eye is drawn to a huge number 9 in left field. Created by groundskeeper David Mellor, it is 77 feet by 36 feet and set with white carnations, roses, and baby's breath. Mural-size photographs adorn the wall, depicting various phases of Ted's 83 years. (Courtesy of the Boston Red Sox.)

Ted's number appears nostalgically in the at-bat lights for the last time on the old scoreboard. Two young Red Sox fans, who had only read or heard about the exploits of the Splendid Splinter, take in the scene. (Courtesy of Bill Nowlin.)

Manager Grady Little displays the 9 on his right sleeve that the Red Sox would wear for the remainder of the 2002 season, his first of two years as field boss in Boston. Little had been bench coach under Jimy Williams from 1997 to 1999. (Courtesy of Bill Nowlin.)

Ted's nephews Sam (left) and John Theodore "Ted" Williams attended the commemoration of their uncle's life at Fenway Park. They are two of the three sons of Ted's late younger and oft-troubled brother, Danny, who died of leukemia in March 1960. (Courtesy of Bill Nowlin.)

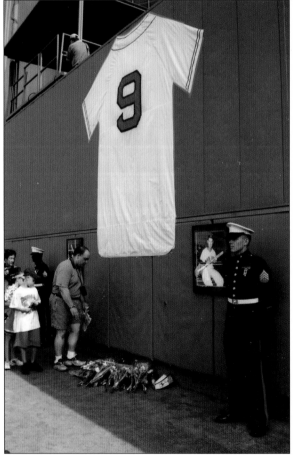

Some fans attending the memorial event at Fenway Park were unaware of the story behind the red seat in right field bleachers Section 42, Row 37, Seat 21. That is where the longest home run in Fenway history struck. It was 502 feet from home plate, and the ball was hit by Ted Williams on June 9, 1946. It deflected off the straw hat of Joe Boucher, a Yankees fan from Albany, New York. (Courtesy of Bill Nowlin.)

An appropriately larger-than-life jersey hangs on the center field wall as fans below pay homage to the man whose larger-than-life persona enthralled generations of Boston fans. When the night filled with raw emotion came to a close, fans filed out of Fenway to the playing of "Auld Lang Syne." (Courtesy of Bill Nowlin.)

Steps led up 100 feet from the Miramichi River to Ted's hideaway, in which he welcomed friends from all walks of life. Louise Kaufman, Ted's live-in love for 20 years until her passing in 1993, also was an accomplished angler and spent time at the cabin. Ted's granite-like profile and that of longtime friend and fishing and hunting companion Bud Leavitt make a stunning portrait, which Ted autographed for Leavitt. A sportswriter and editor from Maine, Leavitt met Ted in the Red Sox dugout at Fenway Park during the Kid's rookie year, 1939. (Right, courtesy of Bill Nowlin; below, courtesy of the Sports Museum of New England.)

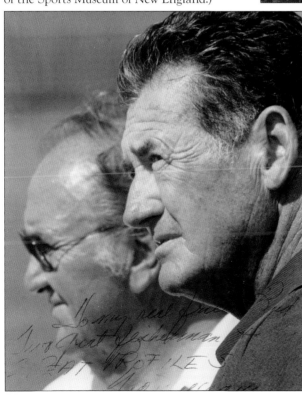

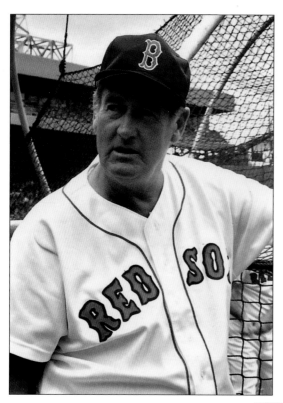

Ted soaks up the atmosphere of an old-timers game at Fenway Park before stepping into the batter's box for some pregame licks.

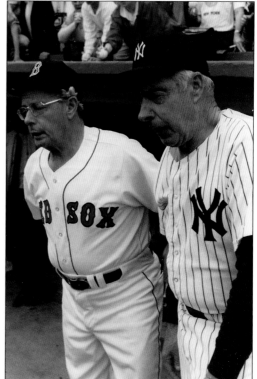

It was not always apparent with a quick glance that Dom, left, and Joe DiMaggio were brothers. But this photograph from the 1986 old-timers game in Boston leaves no doubt that they were indeed siblings.

In Florida, where Ted spent a large portion of his life, a stretch of road is named in his honor. The colorful sign reads: "Ted Williams Parkway / On Norvell Bryant Highway / Dedicated By / Board of County Commissioners 2002." (Courtesy of Bill Nowlin.)

The Kid cuts past a throng of well-wishers while entering the grounds of the hall of fame in July 1985. He did stop to sign a few autographs.

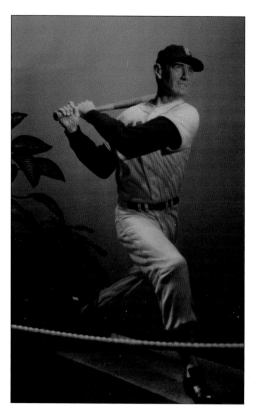

Peering at this lifelike, life-size statue of Ted in the National Baseball Hall of Fame, a visitor could believe that Ted is wearing a genuine uniform made of fabric. However, sculptor Armand LaMontagne has it painted and carved from a 1,400-pound block of laminated basswood. The belt loops, the buttons, the shoes contribute to a piece so lifelike, someone would think this Ted could speak. LaMontagne said he portrayed Williams in the 1950s when Ted was in his 30s. Ted posed five times to ensure such magnificent details.

Uh-oh, Ted saw something he did not like, evoking what became a scowl, standard operating behavior in his younger days but a rarity in the face of the author's camera. That look quickly disappeared when he engaged fellow ex–Red Sox teammates in civil, light-hearted conversations before the 1984 old-timers game at Fenway Park. Ted initially was reluctant to attend the first Old-Timers Day in 1982, but he accepted the invitation out of respect for Red Sox owner Tom Yawkey. The game commemorated the 50th anniversary of Yawkey's purchase of the team.

EPILOGUE

In 1943, Ed Neiterman was a 15-year-old high school student living in Brighton, Massachusetts, when he wrote a letter to Ted, who was 24 and in flight training during World War II in Amherst, Massachusetts. Neiterman, who turned 85 on October 24, 2014, does not recall exactly what he wrote, but he did not expect Ted to reply. He did, and Ted's letter, dated February 1, 1943, is found on the following page. (The letter is copied just as Ted wrote it, spelling errors and all.) Neiterman, a retired accountant who has lived in Walpole, Massachusetts, for 34 years, does not remember his reaction to seeing Ted's letter in his mailbox when he arrived home from school, "but," he said, "I do know I didn't do my homework that night." Neiterman went to a Jimmy Fund function in 1986, when he had Ted autograph the letter. Later he placed it safely in a frame. In another twist, Neiterman's only child, Steven, attended Ted's camp from 1968 to 1978 as a camper and coach. Steven was a senior project manager at MIT when he died of a viral infection in 1998. He was 39.

Williams wrote the following to Ed: "Dear Ed: These are just a few lines to let you know I received your letter and to thank you for all the kind words. As you probably know Pesky, Sain and Gremp the later two were with the Braves are all up here and there all getting along fine. The weather been so bad than were having a tough time getting our flying in which we all like so well. You know Ed as a rule I dont write because I can't answer all my letters but when I read yours I just decided to answer yours because you sounded like you wasn't one of those meathead wolfs that howl there lungs out when they get to the ballpark. Anyway I'll close hoping to see you some day at Fenway when all this mess is over. As ever[,] Ted."

Feb. 1, 1943

Dear Ed:—
These are just a few lines to let you know I recieved your letter & to thank you for all the kind words
As you probably know Pesky, Sain & Gremp the later two were with the Braves are all up here & there all getting along fine. The weather been so bad than were having a tough time getting our

flying in which we all like so well.
You know Ed as a rule I dont write because I can't answer all my letters but when I read yours I just decided to answer yours because you sounded like you wasn't one of those meathead wolfs that howl there lungs out when they get to the ballpark.
Anyway I'll close hoping to see you some day at Fenway when all this mess is over.
As ever
Ted.

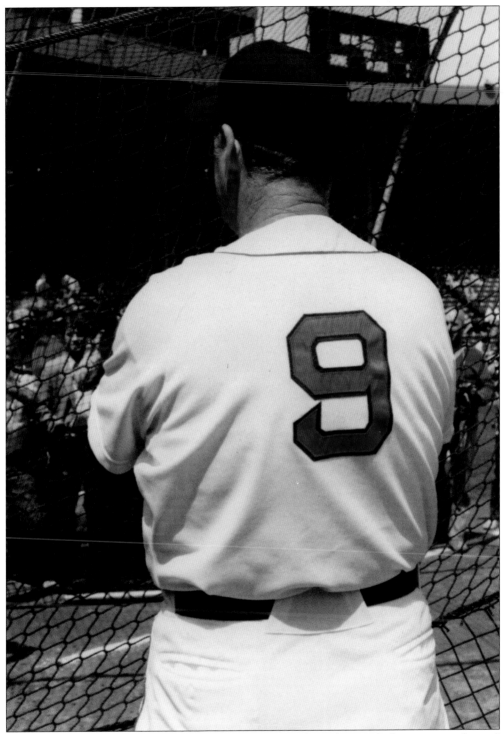

Author John Updike's assertion in "Hub Fans Bid Kid Adieu" that "gods do not answer letters" clearly did not apply here. Ed Neiterman's treasured letter from his hero, Ted Williams, bears testimony to that.

DISCOVER THOUSANDS OF LOCAL HISTORY BOOKS FEATURING MILLIONS OF VINTAGE IMAGES

Arcadia Publishing, the leading local history publisher in the United States, is committed to making history accessible and meaningful through publishing books that celebrate and preserve the heritage of America's people and places.

Find more books like this at
www.arcadiapublishing.com

Search for your hometown history, your old stomping grounds, and even your favorite sports team.